POEMS and drawing JACK SHEAD BOLT

DISCARDED

Mind's I

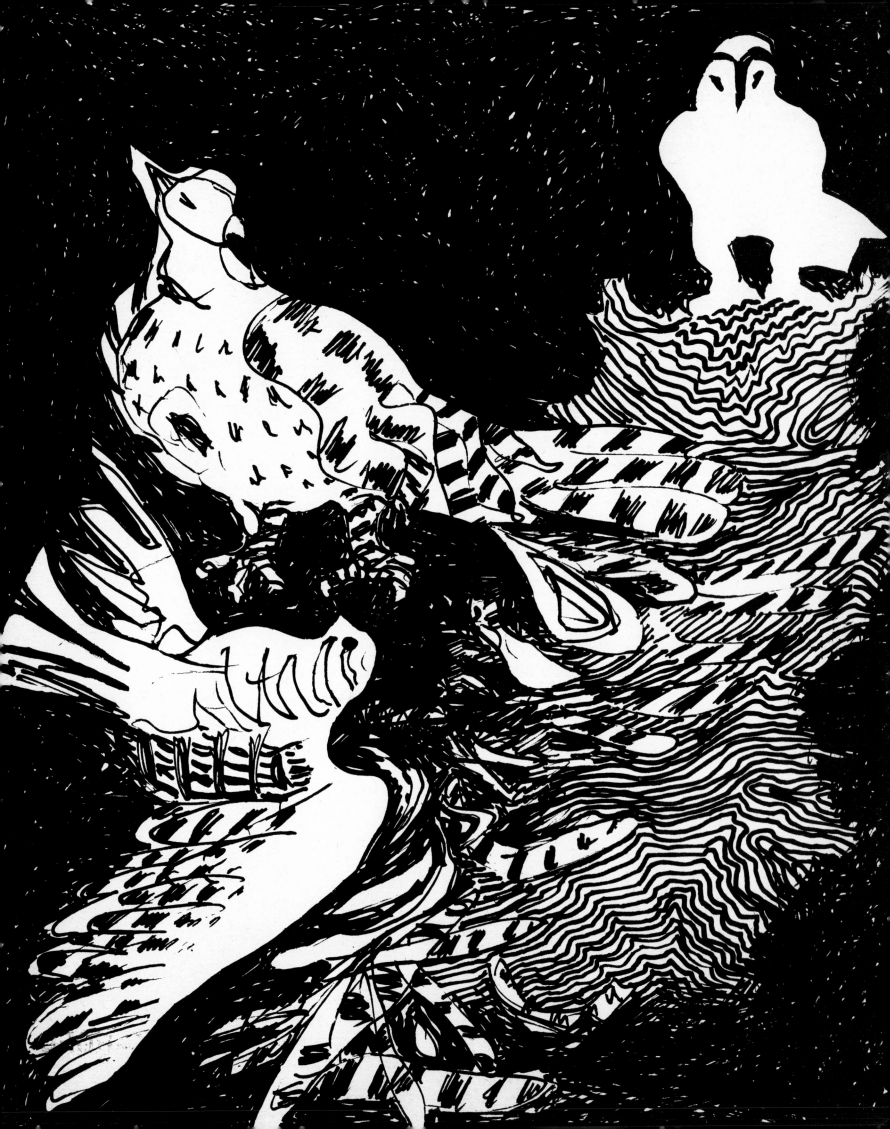

PS
8587
.H23 M5
1973

Mind's I

POEMS and drawings JACK SHADBOLT

McClelland and Stewart Limited

 DISCARDED
THE
UNIVERSITY OF WINNIPEG
PORTAGE & BALMORAL
WINNIPEG 2, MAN. CANADA

For Doris

Copyright © 1973 by Jack Shadbolt

All rights reserved

0-7710-8117-0

The Canadian Publishers
McClelland and Stewart Limited
Illustrated Book Division
25 Hollinger Road, Toronto

Photo of Jack Shadbolt by Bill Goldman

Printed and bound in Canada

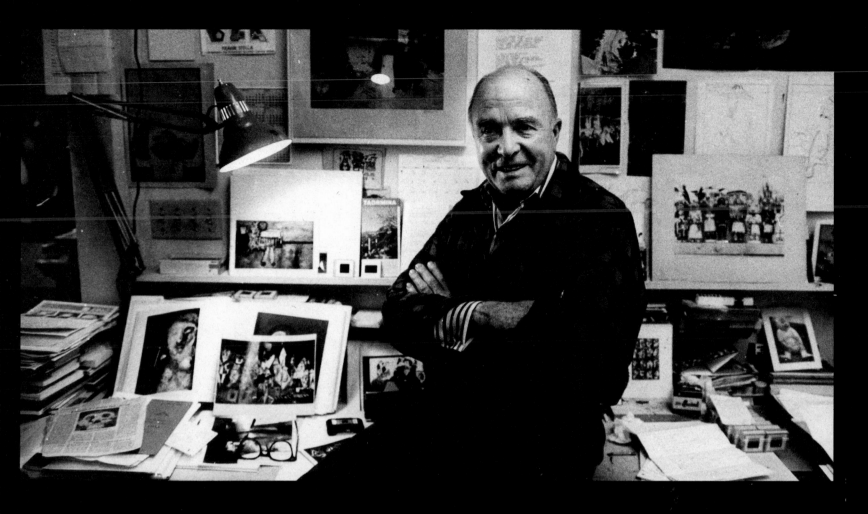

Mind's I is infinitely variable
The I you think you know
or seem to see in me
is but the I that I am forced to be
because both physically
and mentally
and socially
I am conditioned me
Yet even as I speak with you
or you with me
my inward I acts out
the role it needs must play
to comprehend reality

My psychic needs exist beyond
dimensions of prosaic me
too practical for mystery
too confirmed for tolerance
too timid for the great event
too human-scale for destiny

but as my poet I
there I live dangerously
love gloriously
laugh knowingly
speak wittily
or through my artist I
the world transforms
in splendid imagery
or as my mystic I
I sense the cosmic unity
or as the dreamer I
I can with vivid fantasy
transpose my actuality
and with my sociological I
ah there is where I see
victims of destiny
and when I am disturbed by what I see
I turn the other I
the eye of the absurd

The normal ego I
can see only what I know
With something strange and new
I shift my point of view
assume its new identity
and from inside its mind
look out on what I see

Sometimes I am a chink
or nigger or my neighbour
or the dog or a bee
or my wife looking at me
and there are times
the shutter moves too fast
Before I've time to hide
the naked I
flashes naked me

1972

5

Introduction

As a young artist trying to distil meaning from experience I worked for a time at poetry almost as much as I painted. The attempts to write gave me a severe chastening as I realized all too well the enormous discipline of mind and craft involved in literary compression. But I had developed a love for poetry even though I was scarcely to look at my early efforts or to write poetry in the interval of up to forty years between then and now.

I craved images of simplicity but also of depth-charge expansiveness for the mind and of enigmatic mystery to hold the imagination. I felt I had begun to learn how to approach these qualities through visual abstraction; but in thinking of poetry I never dared hope to come near it. Yet all the time I was painting I would be mulling over this miracle of thought-word-image transformation.

Only recently was I encouraged to re-examine what had always been so natural to me — this duality of conceptual impulses in which visual and poetic imageries are almost interchangeable. I exhumed my earlier body of poetry and was surprised to find the basic lyricism sound. Of course I had to change a word or a phrase here and there or knock out a cushioning adjective but on the whole the conceptions stood up. I have presented these poems with their dates as a matter of interest to those persons who asked me to elaborate on the cross-connection between my painting and my feeling for poetry hinted at in my book on the artist's conceptual cycles, *In Search of Form*.

The reader will observe that certain words or images re-occur in differing contexts or alternative versions of poems. I have not edited these out because they indicate something of the learning and shaping process parallel to that in my painting.

As I started writing again, I began quite naturally to draw along with it. There was no one-to-one illustrative connection between individual poems and drawings but only spontaneous generation from similar sources creating parallel moods. I am quite aware of the dispiriting historical record of trying to *illustrate* poetry. This book is merely the evidence of an interlude where both poetic and visual rhythms were sustained side by side until there emerged between them a new entity compounded of both. I had no original intention of producing a book but as the work continued the book format presented itself as the resolution of the new emergence — reaffirming for me once again that my form always develops from a dialogue of opposites.

Vancouver, B.C.
1972

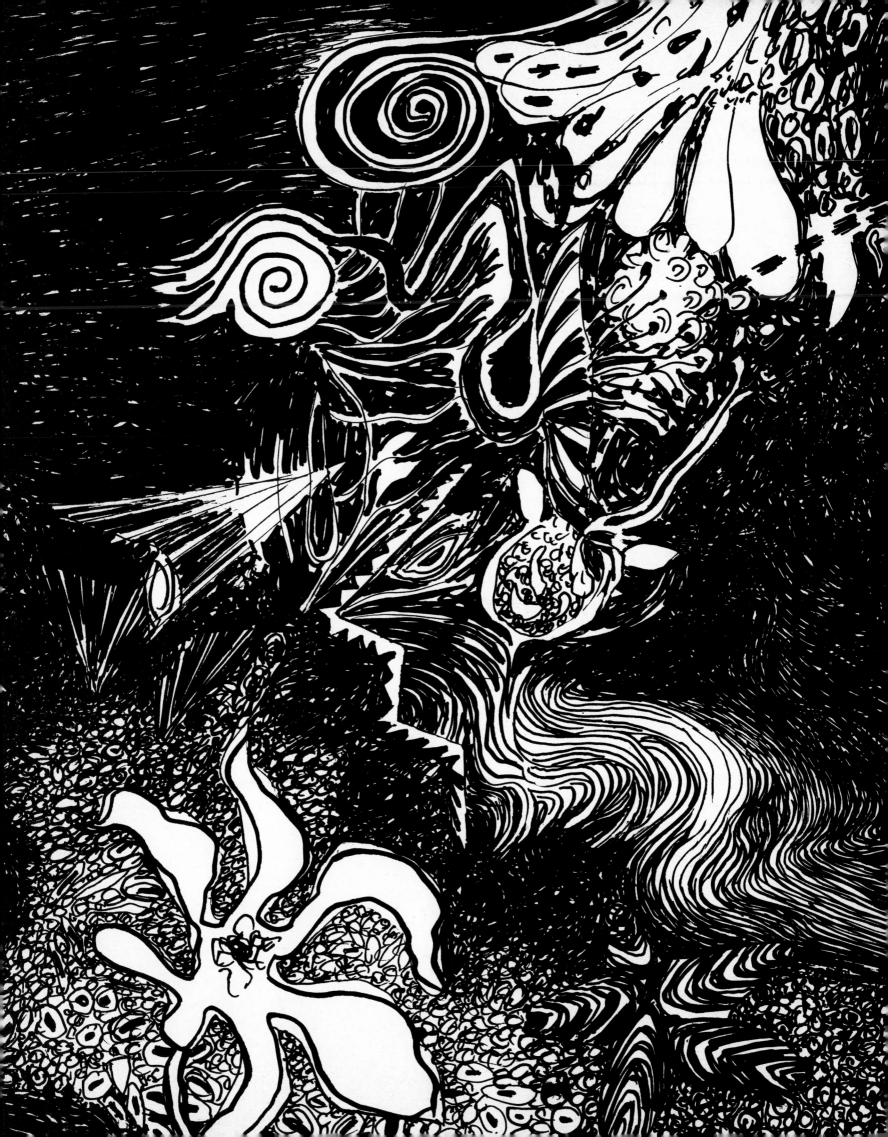

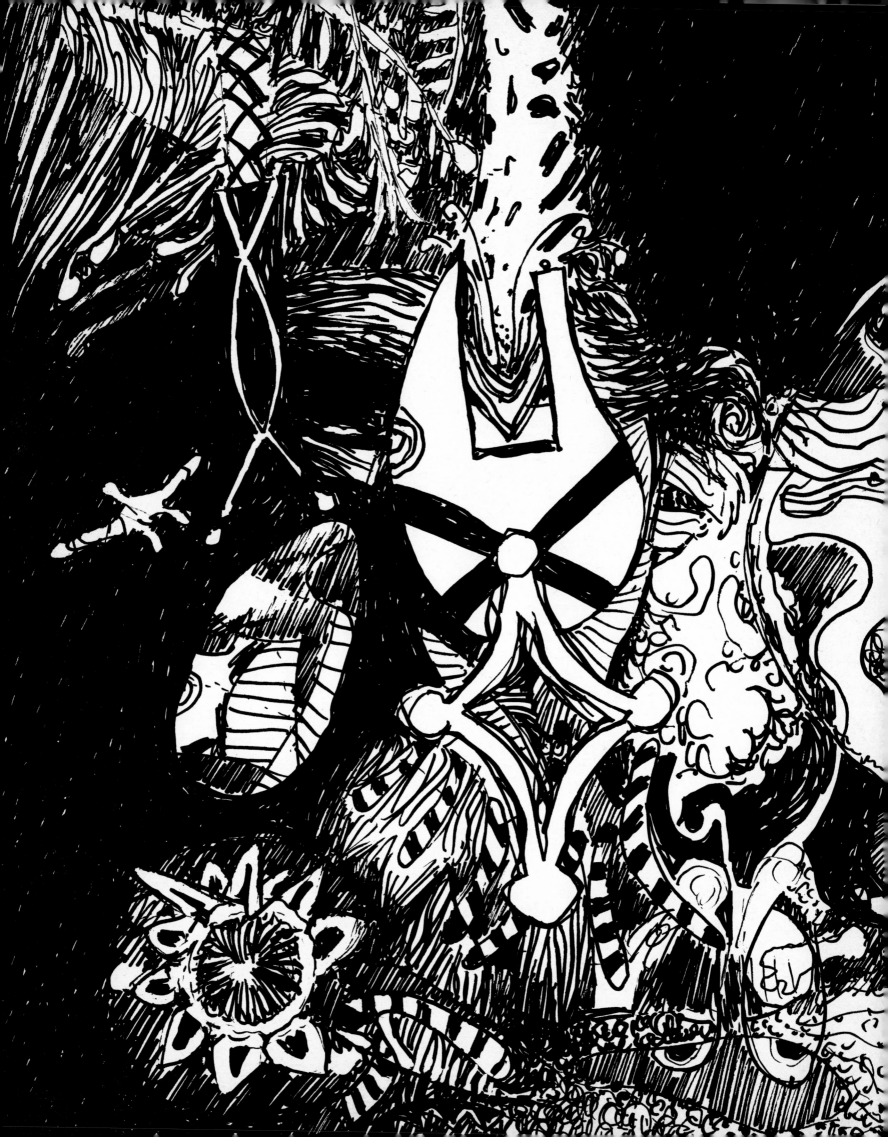

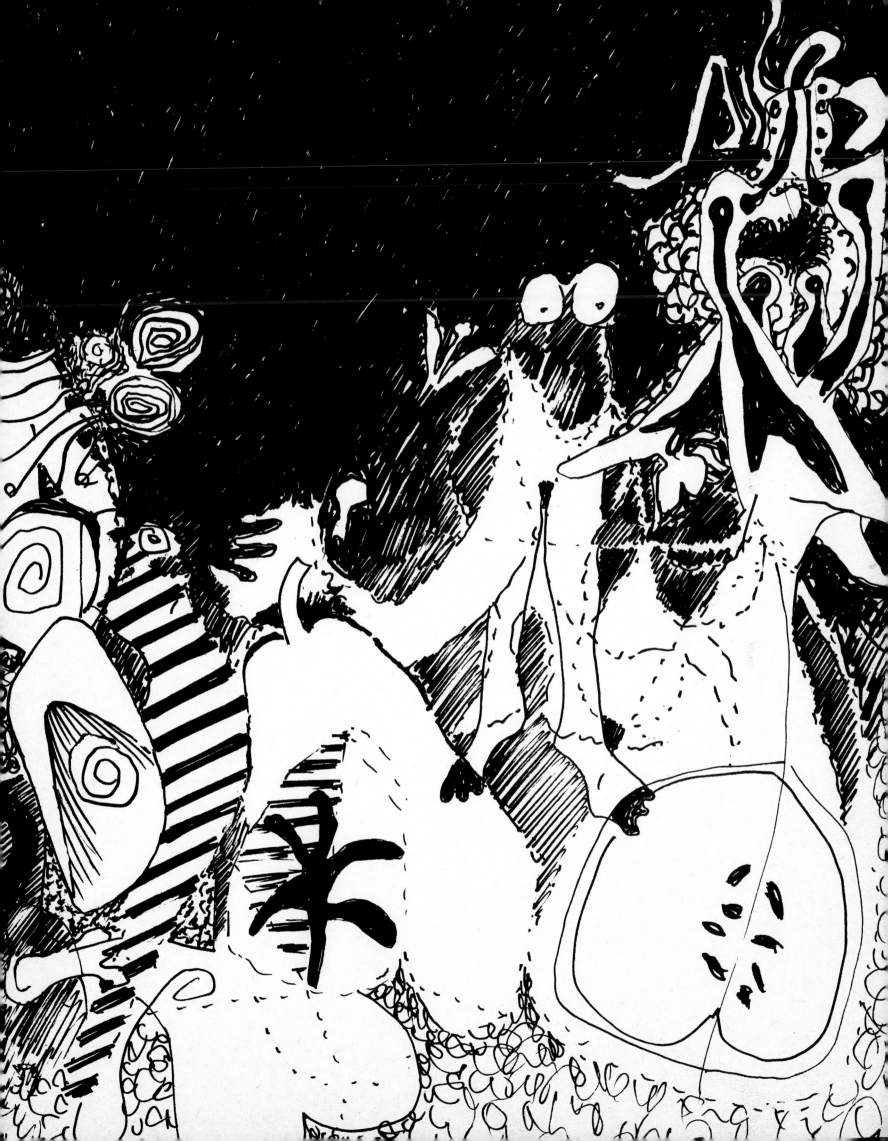

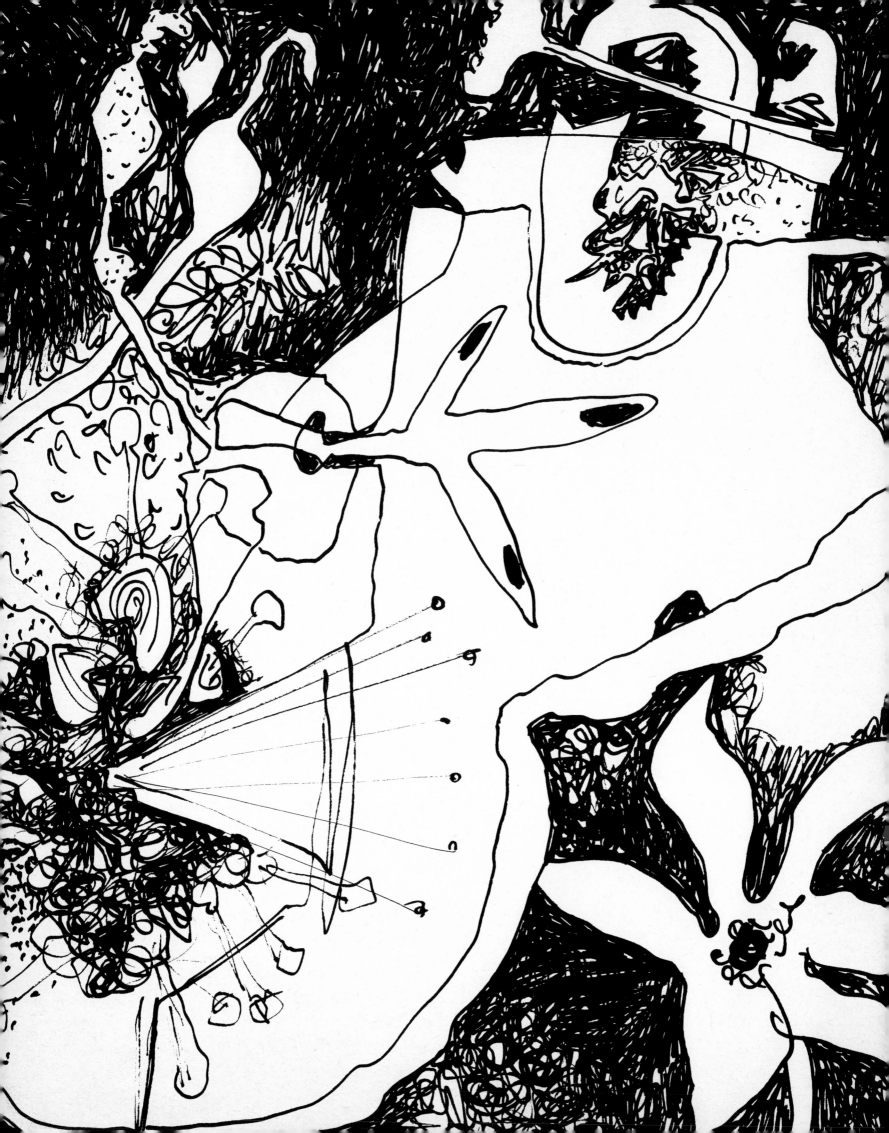

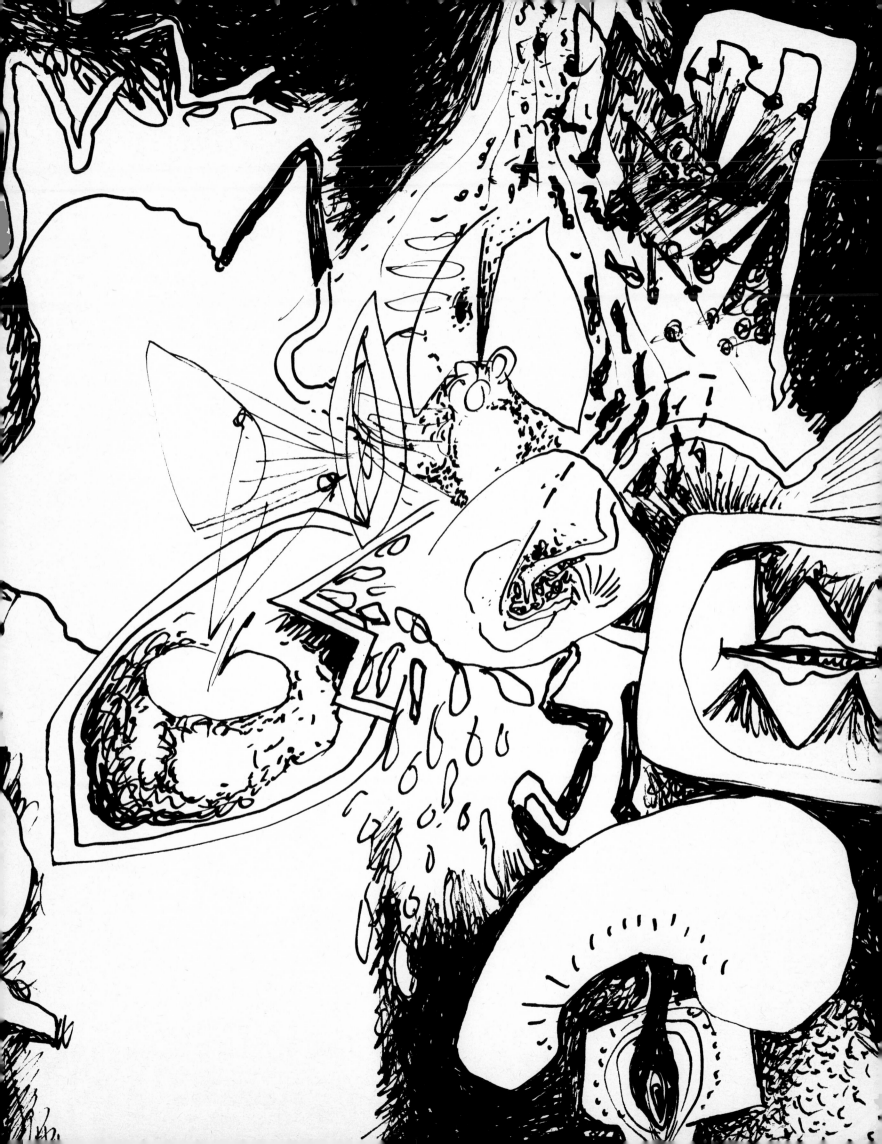

You found me in the sun
an open flower
Had not your swift hover
with never an alert
(gentle buzz or angry drone)
to warn extended petal
taken me unawares
I should have been
and you known
more subtle a lover

There was my heart exposed
my bower sweet
and sweet too was possession
I (and this be my confession)
kept you too close pressed
for when in season
I was folded in
still you were there
possessor and possessed
Yet could I bear to have opened
or you drugged to have flown
when frost held the outer air?

So you lay all the dark days
wintering in my breast
until my petal arms
too numb longer to hold
were shed
and what was you in me
was dead

1936

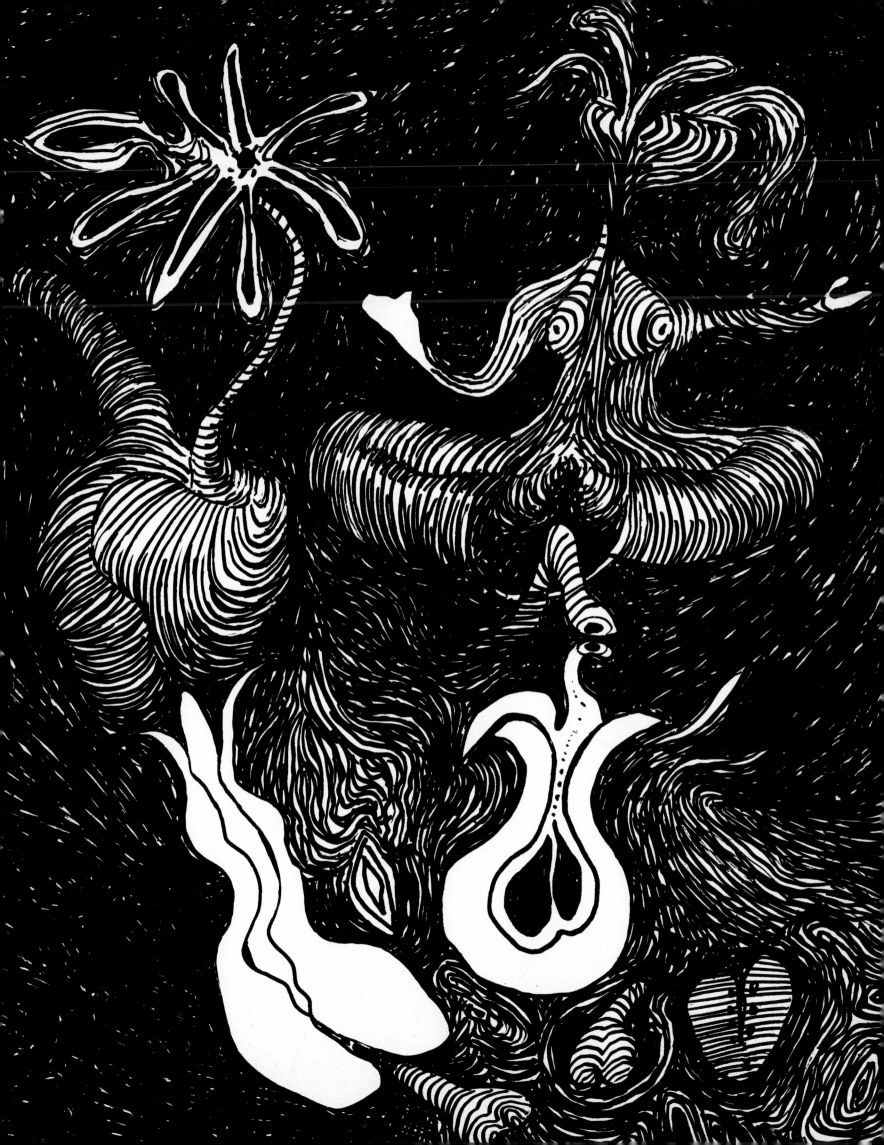

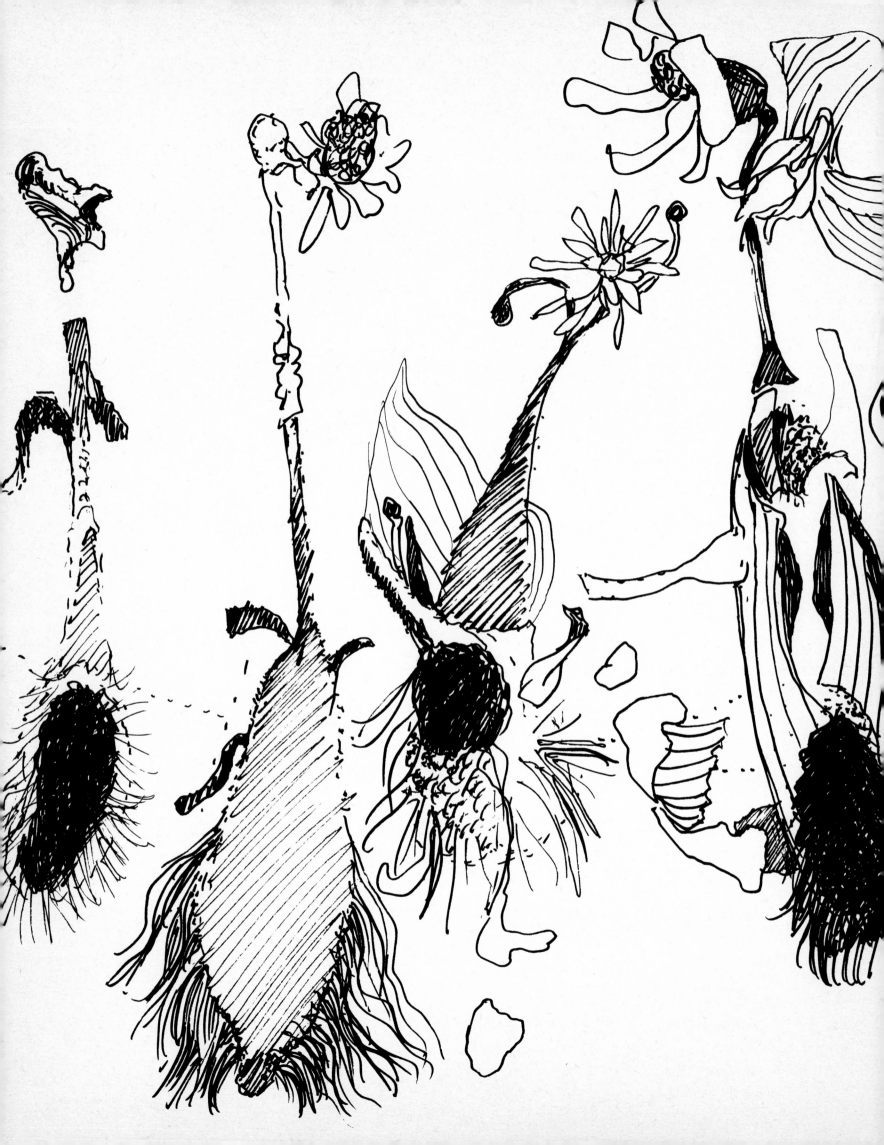

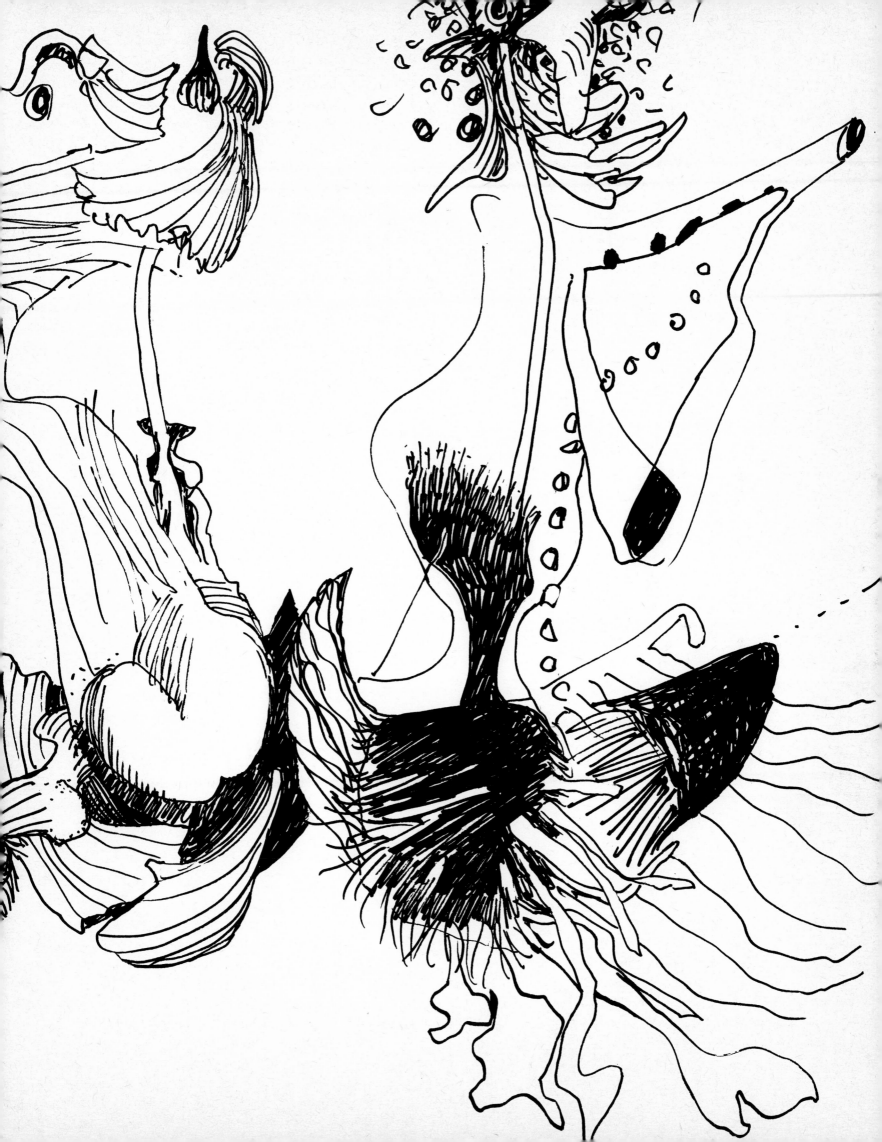

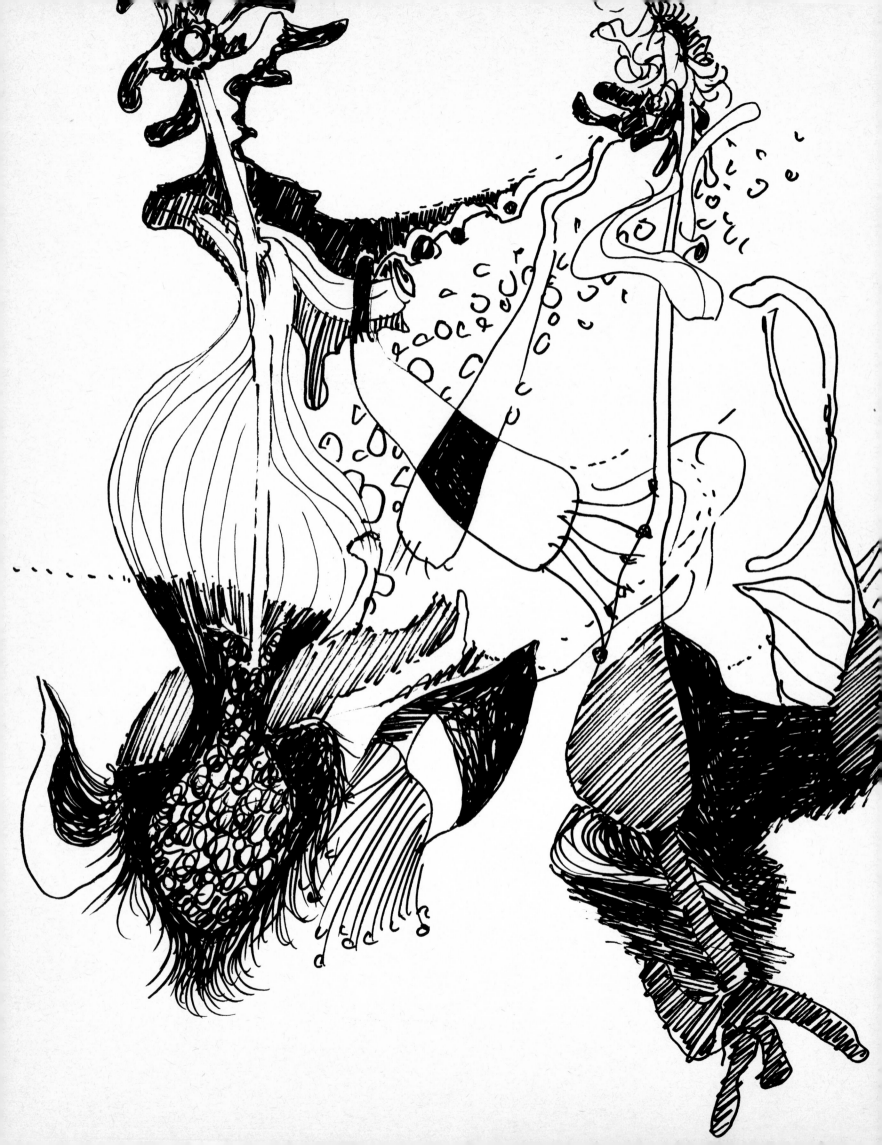

*

Do not make me say
Burble if we must
love's lovely stupid names
Speak with sighs and eyes
and lips and bodies whole
Let us have no words to trap us in
Nothing to recall if it should end
but the ecstatic trance
by which we were inflamed
Asking what we mean
is setting words between
words that can betray
for fear those lips that say
today I love
by very repetition can imply
when tired or bored
I love less or
I love no more

Kiss and do not speak
The chilling bite of words'
precise inflections
can be bleak
when in the sun of love
quick hearts open like live buds

*

In daylight at the dock today
we dare not look
we could not speak
since words but etch designs of sorrow
so we laughed
smote at the bitter barrier
yet weakly
knowing in our silence
had speech come
grief's dam against tomorrow
would have crumpled
and our words not long contain
the dark flood's rush
you having gone

*

Goodbyes are such finality
that I must hate them
Rather would I go not knowing you had gone
tomorrow I would wake
and they would say she left
and I would go into the hills
hearing the stiff pines crackle to the wind

You're here there is no need to say I love
no thought of loving or of not
no promises to keep
Our presences are dumb sufficiency
Imperative farewells command us speak
of those things dear we have not known 'till now
and oh in telling
how they hover beyond the tongue
how they will home when you have gone

1936

17

Better not to ask me if I love you
Never try to know
what I would have you be
Be as you must
because in being you
I most am being me
I wear you in my eyes
Everywhere I go
I breathe you in the air
Near and far
are merely where you are
and where I am
Space is now defined
precisely by the mind
To think of you is near
remembering is far
The present is you here
there is no past
You fill my wide horizon
like a prairie sky
The reaches of my you
are vast
but crystal clear
You are the stars that tingle
and the moon that I
the cosmonaut
draw near
You are the voices in my void
your moods are gay or solemn
Ravishingly sweet you are
the siren singing
echo calling
ringing in my ears
I hear you like a conch
reflects the distant sea
Because I am attuned
to only you

your voice is whispering
around my room
Whenever in a pause I hear
my heart's steady throb
you then are pulsing near
your heart beats in my blood
I wear your contours
on my fingertips
I wear you in the evening breeze
of floating hair
I wear the flutter of your lids
like summer butterflies
I wear your walk
like arum lilies of my youth
curvingly erect
The daisied meadows that I knew
when I was young
you are —
the wild orchids in the wood
the tiger lilies in the shade
and then you are
the bluebells and the buttercups
There is no end to what you are in me
for every fibre
every memory
vibrates to you
and every part of me
that's touched alive by you
is what I am and what I do

Therefore no more words
let the mood be gay
let the deeper levels
play as they will play
Words can be conundrums
Sense but do not say
that we are each to other
just what we unknowingly
have made each other be
And yet our equilibrium
exists when each is free

1936-71

*

I'm told a man new blind
shaving with no mirror
cuts himself
His mirror fetched
habit controls
and he continues easily

Since you are gone
habit and I go on
but sometimes when by thought
you are not here
who mirrored me
who blind as I?

And going to my room
at night I
like the blind
who switches on the light
because he cannot see
conjure your image bright
to reassure my mind

But soon floods back the dark
and night unkind

1935

*

The phantoms of our youth
that urge the vital flesh
to young love's lust
now too are weary
of their non-success with us
Soon could our bodies be
but withered testaments
under erotic tombs to lechery
in some exotic cemetery of love

After this ravaged interlude
inflamed desire expires
We both know openly
we cannot long endure
to prize possess
and then not consummate
yet in our mutual need
born of a mutual fear
that our numb dream
we both have shared
could go the way
of wayward flesh
we move into a sphere
of new respect
too vague too strong
to quite define
but we both know
is firm reality
Lust moves its mountainous wedge
and that between us
for so long denied
now floods the room with simple tears
that are both pain and hope

1970

Reunion

The road across the years was grim
When you (the sun) went down
the rocks of doubt loomed black
There was a time of tears
I crossed the fen
There was the fight with wind
when anger smote
the clutch at the very edge
of the gorge
where grief and dark
incestuously twined
There were the lost high tracks
with only sheep bones
white with weather
berries bitter-pipped
Then shoots sweet-tipped
but the forked trail
and the grim decision
desert voices beckoning back
galled feet
raw sores
and pale pain's gnaw
to keep the mind
from thinking of the things behind
the moving silently and blind
for fear the quick heart
quailed at the deadly ambush
Every path was fell with memories

But now I am across
only the acid trace
of fear's thin sweat
betrays me as I search your face
The fantasies will pass
You're here
I was not sure

1934

*

Here on this concrete roof
high above my Paris
starlings at the cornices
naggingly chatter
The imminence of her
is palpable when
jewels as bright as fire
in each bold pane
inflame the dusk
and shout her name

She is most with me
yet she is not here
where used to be our rendezvous
Some mere and yet persistent whim
teased us apart
Dark's tentacles choke off
our separate days

In two brief weeks we shall be gone

Beneath this vast sky
should be our vaster hours
to send us singing home
but only these
maddening starlings
echo our sad anger
Night moves slowly only
toward thought's perpetual danger

Prepare the bed
Await the bride
Caress the stranger

1938

Dimensions

The milk of dawn is sour
and curdles into day
Across the harbour in an hour
will be a birth
no contraceptive loop
nor pill
nor any known device
could have prevented
hastened or delayed
It is the birth of light

Nor could a probing analyst
unravelling by dream
or symbol states
interpret how I feel
here by this gently ebbing sea
the shore of time
my space my time
after a night of
wide awake
thinking of you and me
and where we went astray

nor could the physicist
with all his instruments and
his elaborate device for
measuring the space
determine quite the space I'm in
within my lost self

nor could the systems analyst
by any known survey
project the complex reasoning
accounting for the why and how
the day stands tall to me
and wide and high
and I am finding in the sky
a new dimension of my emptiness

1936-72

*

The harbour dies toward the night
wreathed in a brown-gold smoke
like coiled fumes of heat across
the crinkled scum
of crucibled lead

I heave a dying sigh
and turn once more to bed
The brain's persistent linotype
goes click and clack
as molten words recalled
are hardened into thought
along the memory racks

Whatever may be scanned
in the morning edition of me
when I am proof-read for the truth
by the unsparing day
it will not be in faded type
romantic on the yellowed page
but blazed in headline bold
for any fool to see
She left her print on me

1935

Letter

Early this AM
I strode across a field
ground mist swathing knees
wet boots all ashine
with limpid sun
when all at once
for no good reason I could name
a morning lark
relinquished to the air
so bright so clear
in liquidescent climb
his tensile song
ten meadows long
before the dying fall
that I knew things were right
and shouted my acclaim
to the awakening sky

Such moments (I confess
not many since you left)
I shore against the times
when I have known the meadow's rind
iron to the heel
the heart as hard as ice
No song of mine climbed skyward
like this escalating lark's
sheer pristine call
Legs
breasts
belly and behind
were all I croaked
into the harsh frozen air
the simple words
my complicated bitch
for that which itched my mind

1939

Curious how heart commands and
feet follow sand's
thousand upon thousand hollows
Beach-bird wise
from log to log I hop
or like a dog I stop
to check the littered waterline
for mindless miles

Deviously
by this extended way
to the bluff beyond the bay
I know that I will climb
the boned cliff's scar
to that high field
white-stoned among the dead
the ancient cemetery
wide to grey waves
and tide
Barren reef
low thunder
graves grey-silver
wild grass frenzied white
as rocks rimed with sea-salt are
and dried as past tears of grief

Merely an episode
so much a part of me?
Is it dead? Done?

Stone drops
rock pool trembles far below
Hard on wind
harsh pack screaming of
black crows over me
hurtling steep ledge
down to foam-lipped edge of sea

Down I go by
red shed on bleak rocks to
Hidden creviced beach
Heart on foam-flower stalks feeding
dead in leaf

Words (a philosopher said)
to disguise our thoughts —
Handful of embers
stuck in throat
at dock's end
Then you left
Now words grey
granite
adamant are
crushed in heart again
smashed on teeth by wind

Fire on rocks
Kindled wind
snatches flame
then
white smoke to white sky
streaming
searing the eye

1937

24

Near and Far

Avid for the last gules
of honey for the last
bite of toast before
the first morning smoke
it comes to me
this thin screech of knife
across my plate is the forlorn
screech of gulls across the rocks
and sharply I am there
in summer at the Island
and I see again so vividly
her face

Secret name?
No one could ever know from me
I never knew myself
Nor how that instant moment when
at the top of the rock
she appeared
and in the wind
her hair swirling
turned
would penetrate me so
nor her intense searching smile
as we paused
then passed

I've never seen her since
Yet vividly this
acrid vapour of my cigarette
is brine stinging in the eyes
as I move on around the point
and she has gone her way

I think of her just there
in that explicit moment of encounter
Why?

And why
in butting out my cigarette
I poke a cold beach fire's
yet unextinguished ash?
Things near and far
they sometimes seem the same

In reverie
my heart gently pulses
then too loud too pounding
I can see it is a freighter
throbbing
harbouring below

Things near and far

I hope I never meet
This unknown girl
This fleet phantom memory
is far too near
Dreams are best kept far
and actuality alive and dear
Or are they interchangeably
the tokens of a game
which we enact between?

1972

Morning Death

I am laid
in a desolation of grey
a lost dried valley
of bitter rock
Even if words were not
the ultimate stumble
I could not quite define
my morning death
The shadow of the inchoate
moves over me
I only know it ominously
A tight torpor seizes me
my limbs of immense weight
stretch infinitely away
tired
as though I had been bruised
in some appalling brawl
before unconsciousness
My nerves
hot wires
that tingle at my finger lobes
I am a blasted tree
with a white core of agony
A trance of terror
has reduced my power
to gibbering ineptitude
A pale sweat evaporates
across my brow and I smell
of my stale self

A catalepsy so profound
I neither sleep nor wake
engulfs me
in this morning death
The acid loathing
of my self-disgust
eats all my crevices
I cannot move
I am gripped by
the ultimate terror of solitude
I long for the salt flow
the brine of my self-pity
that will ease
my stinging eyes
my arid throat
and bathe my aching limbs
But I am impotent to sob

All I can do is
not to lean over to her
turn her warm body to me
have her as I know she would
take me in her arms
like a mother
soothing her child's crying
assuring he is not unworthy
he can meet the day
I cannot turn
because I cannot have her know
that I am weak beyond defence
that I will need her smile's strength
here near
believing

So I wait knowing
I will face again
my morning death
alone
checking my heaving breath
hoping I have the guts
never to write this poem

1970

Doors

Friend you have not once
in all the years
that I have known you
ever even one slit
opened the iron door
that guards the secret you
Never has it once
even imperceptibly
moved one fractional inch
to show a merest glimpse
even in greatest stress
Never a light a sound
one indication coming through
Could it be
that you have locked me out
or is it you have locked you in?

I have another friend
who in rare moments
opens his gates wide
onto radiant sky
He has no guard
to that inner door
He is not a citadel
His walls are white
With paradise garden light
enclosed yet in full flower
he has his hedges and his maze
his formal plots
and random pathways
with forget-me-nots
his jasmine-scented bower
and through his inner garden wall
past a hedge of withered roses
is a gate into a field
strewn with poppies

His secret is himself
not what he hides
If I walk
to the poppies' edge I know
beyond will be
a white sand shore
among gorse-strewn rocks
and still beyond
a sea of infinite blue
and across that sea faintly
islands beckoning to explore
He is an open mystery
a door beyond a door
beyond a door

With you there is one ultimate
iron barrier
Will it ever open
or will time
corrode it flake by flake
until it rust away and through
the crevices will emanate
the stale odour of dust
and finally be visible only
a dried stone chamber walled
with the obscene instruments
of your flagellation?

1971

27

Beech Groves

Version I

December now
flamed things forgotten
all has been
since memory has known
white, bowed
Eternity since birds have flown
and with them gone the melody
that stirred these woods
The heart is numb
for their remembered song
But the white glades
remember clashing axe blades
and the sap gush
staining the white grandeur
Proud trees bend now
but recall
When Fall had bared an ice-fang
gleamed with light
the frosted beeches upright
smashed to shining rain
the moon

Version II

This afternoon a late bird's call
scalded across the heart

Tonight again is starless
Fall has bared an ice-fang
gleamed with light
The proud beeches wear
moon's agony of
shining rain

Boughs will bend soon
After their sombre grandeur
beech groves will be
white, bowed, splendid

Forest veins
the sweet sap-hunger
know no longer
but remember
axe blades' gash
and sap-gush stain
Now these bronze glades will know
the solace of snow

1934

Who has seen upon the snow
a scarlet bird
work of frailest jewelled perfection
rarest red
tangible to most minute inspection
newly dead?

Who has felt his eyes
with each tree locked in its december ice
feed upon this color as on flame?
Tell me his name

Who has seen this soft red throat
the beads of jet
in each eye's amber?
Who has held a red bird in his hand
in a white forest
locked in gleaming ice?
Who has carried through a glade
a bird of red?
Who has lain beneath a tree
a bird of red
scarlet on pallid shroud?
Who has seen stiff feathers red
as these stiff wings are now?
Buried in a winter wood
a scarlet bird
hoping that a phoenix-flame
would grow?
Who has felt the red mad mood
when scarlet bird lies dead
upon the snow?

Who has not felt the heart as ice recalling that under all there is the urge to grow?.....I wait, and wait, but know that Across these barren frail things lost to sow. Who has not tried in vain to know that under fields a brown bird's molten call.....all...all...all...all is... Who has not felt the silent doom of woods in snow? Who has not felt the heart

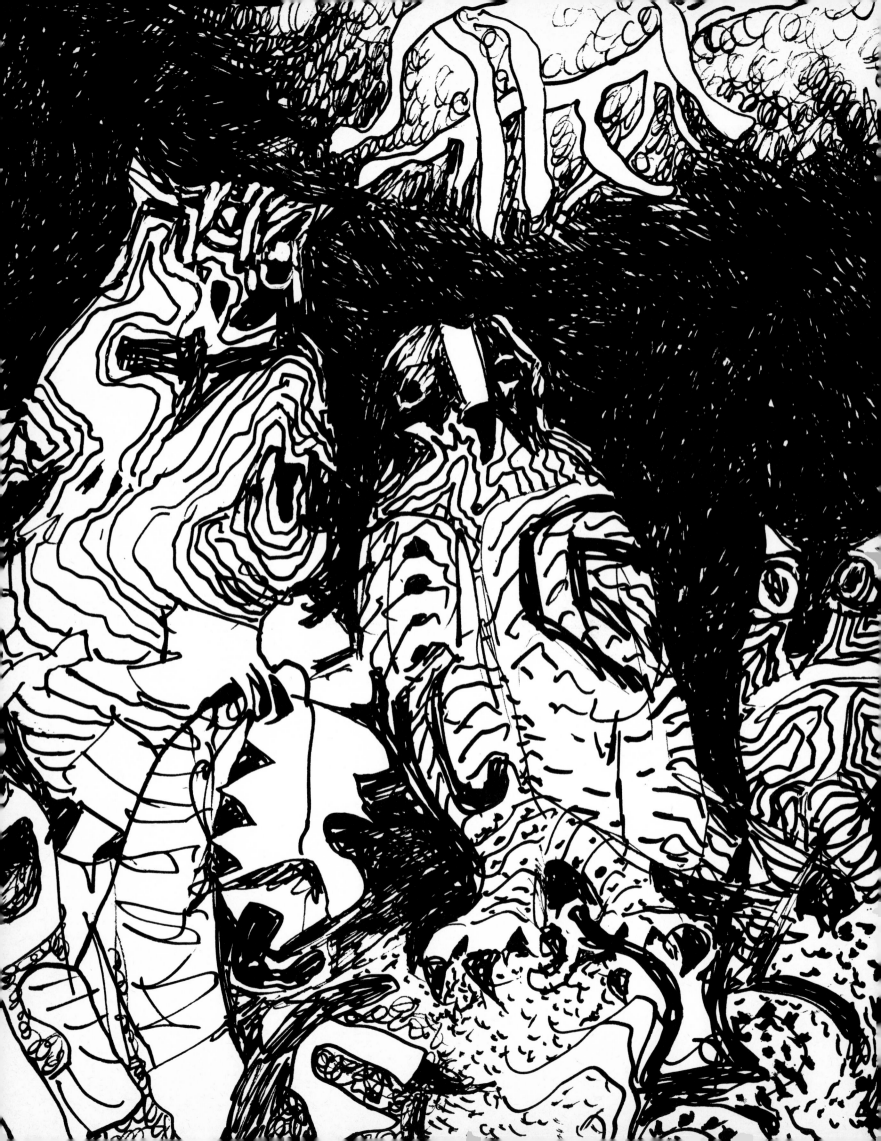

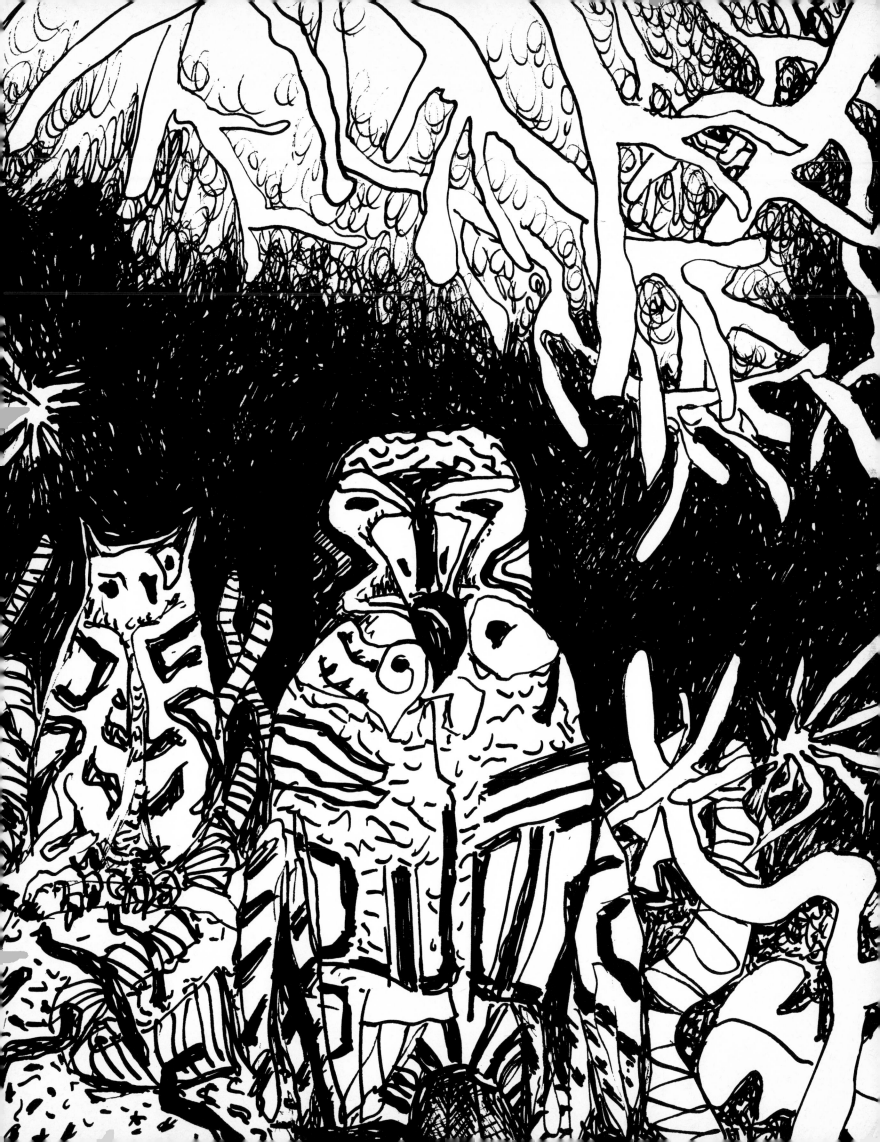

December Woods

Expunge the memories
of all but snow
The summer chitter of the wrens
a lost illusion
Redolence that through these trees
from bird to bird
was linked ecstatic joy
of thrush and warbler and the rest
has echoed down the summer dusks
into a thousand silences of white

All but the tanagers have gone

My still vigil
like a frozen stump
these red birds comprehend
They now communicate
Their speech is flickered
and incessant animation
and in hoarest weather
(as this Saturday here now)
when white boughs are dumb
about a crumb or two
they spark with flecks of flame
the chill gloom

Near me on a limb
perched tensile with
the held-breath skill
of fragile things
this scarlet
jet-eyed
flick-winged
mystery

Beneath my foot
a twig explodes
and then
swift and wing-wise
through fanged-prong branches
with utmost contrariness
the flight

So rapidly he went
I only know
the bent bough
shook white diamonds down
that spears were in the air I breathed
snow's wild white heart
pulsed everywhere 1934

Strange Tale

This afternoon
alone in the forest grey
my footfalls ground the snow
Before I was aware
before me there
a maimed crow lay
"What unholy play"
I said
"flings you at my feet"
in stained red halo?
I will go"
And yet I stayed

Black red white
naked neck clotted with lignum spears
eyes' cold slime and
crusted claws
gruesome horrible bird
dying alone in the forest
unobserved unheard
"What made you die?"

"Crow" I spoke
"You are my Raven
not above my study door
but silent lying on the forest floor
and silent dying
symbol of outcast lives
Harsh discarded shard
darker still than sorrow"

Corveau
blacker than the magic of his symbol
croaked

I nudged him with my toe
He was dead as any crow 1937

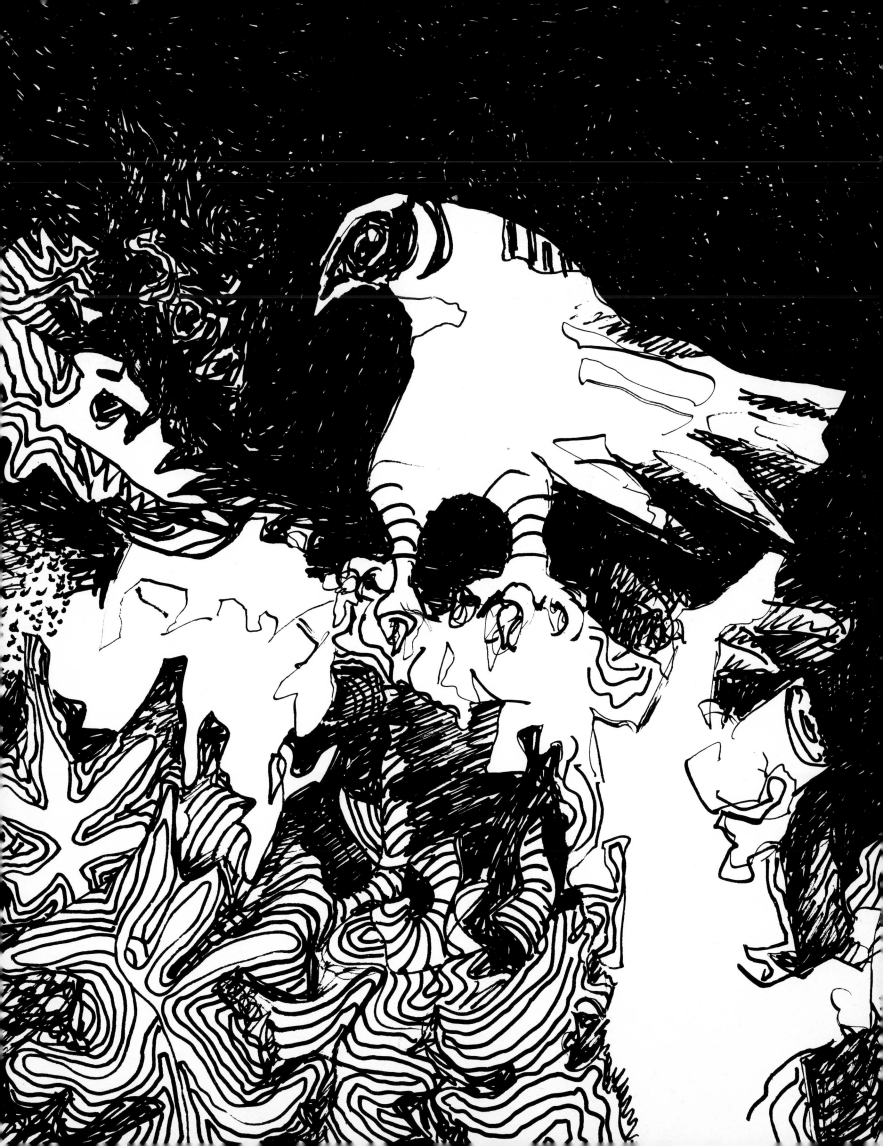

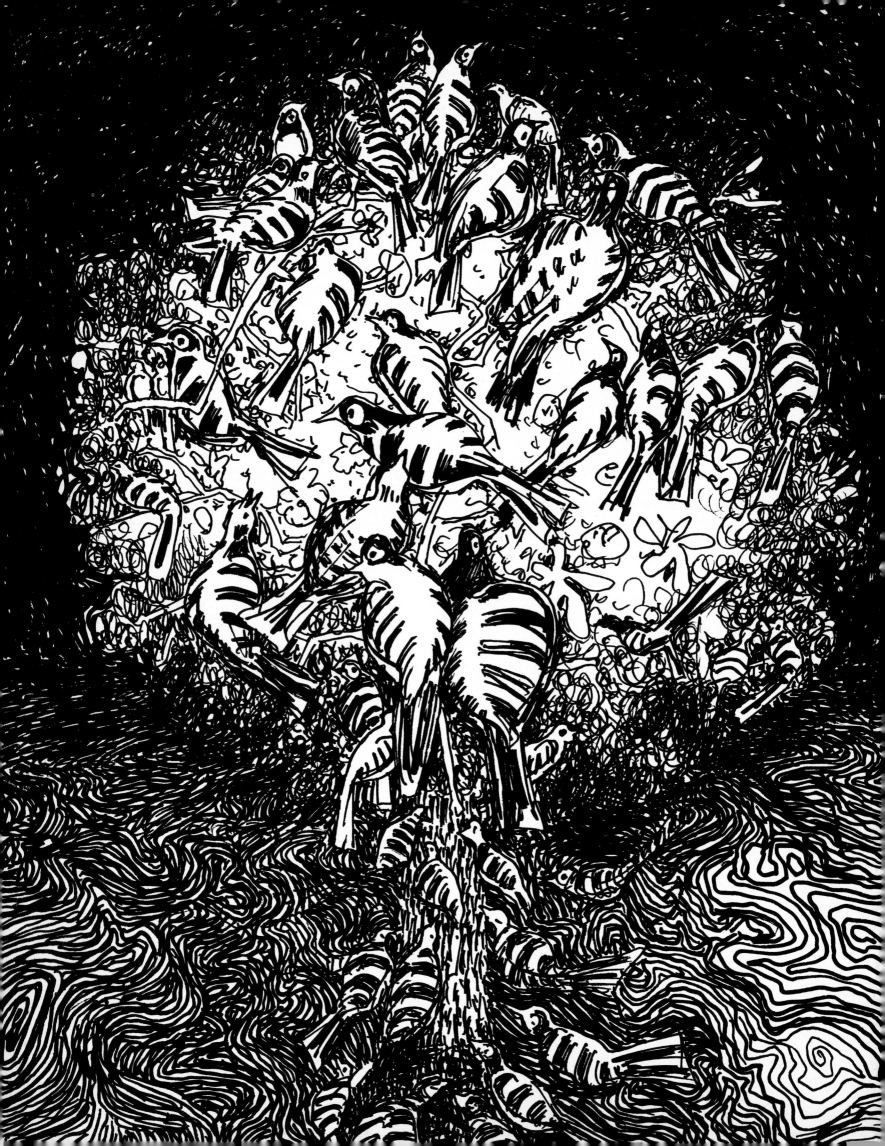

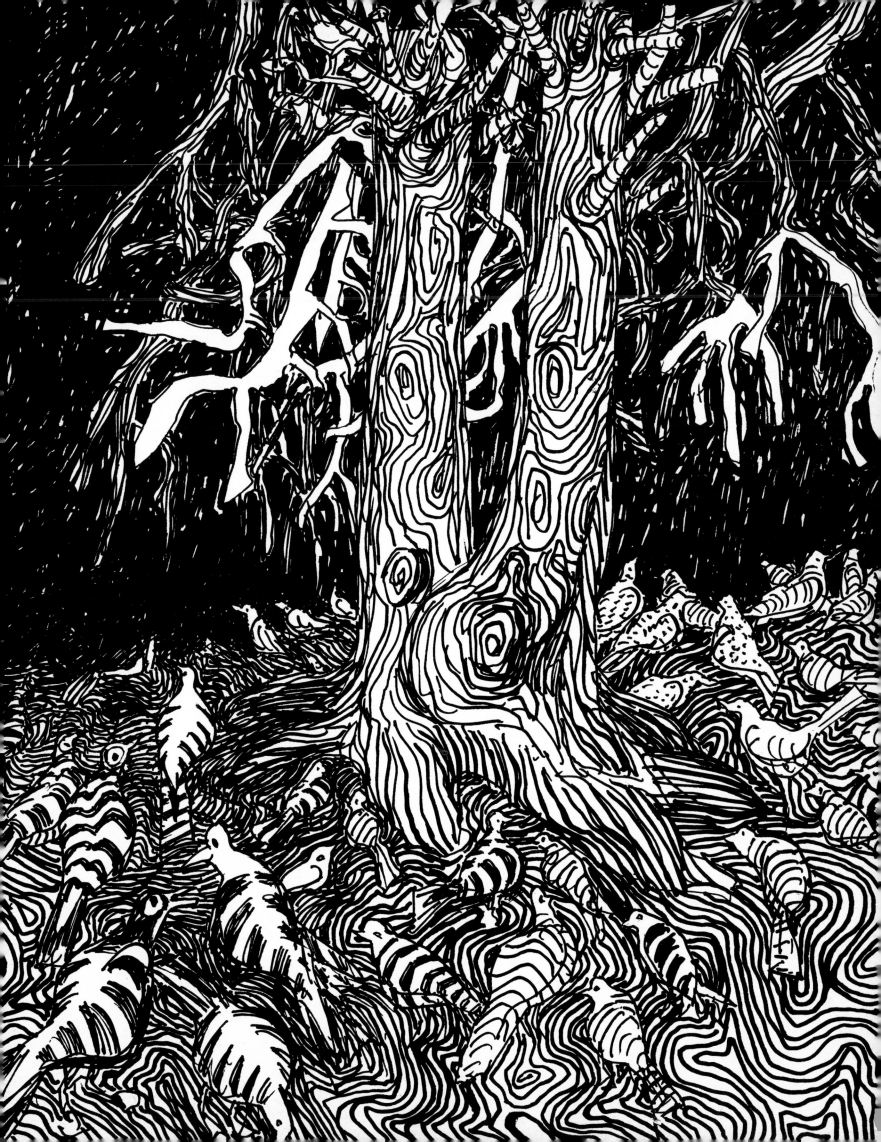

November Afternoon

These spears these domes
constitute spiked pines

This stiff geometry
is house ends stark
roofs lost in sky

Infrangible black prongs
neat-angled limbs thrust wide
the trees

Cold hell
only the eaters of white beauty's heart
could know

All these
Yet melting ever
shadow greys
that but alone by light's fine fading
are conceived
not by things tangible when
soft wild clouds
fall down about the eaves

Then home
I shall be silent
thinking
I have heard the wintry Lynn roar loud
I have watched the bearded faces in the cloud
I have beheld the white houses and the mountain

1934

Interior Winter

How long since you have gone?

I cannot face the evening's fall
staring at your empty chair
while dusk descends
Boiled potatoes
tough chop
desultory fire
staled radio
tired book
I wrench myself alive
push my cramped feet
into stiff boots
assume my duffle coat
and leave the house
heading across the fields

The ground is hard and white
The wind's wane
foretells of ice again
In iron grooves
from tears impending
eyeballs numb with pain

Where is a death more silent
or a whiter dying
than in winter's breath?
What call more searing
than a late bird's scald?
The last light rakes
with gleamed gold
the looming woods

There never comes the fall of snow
but I remember

1934

THE
UNIVERSITY OF WINNIPEG
PORTAGE & BALMORAL
WINNIPEG 2, MAN. CANADA

Incident of Travel

Vaguely
there had loomed the dark plume
but as our mountain road
circled a ravine
entering under tall trees
it was lost to us in rapture
at the high grey light
that filtered down the towering trunks
I on the outside marvelling
the corridors that sloped away
to dim forest caves

The harshness of the land we had come through
the wintry medieval world
had cast its spell
Enchanted as we were we wound
down the soft earth road between
the columned boles lifting
their lichened boughs in
benediction over us
We climbed a gentle rise
feeling the mounting crest
as a skier feels in his limbs
the earth lift beneath the snow then
over and down
along the wooded rim and
out to an open promontory where
electrically transposed
we were instant king and queen
In the royal box
we were numb spectators to
a tragic theme

The valley was the stage
The motor cut
I gripped the queen's hand in
stunned silence now

Registering sharp and clear
the silver-dusted evergreens ranged round
the snow-white floor immaculate
At centre stage two hundred feet below
a towering stem of smoke
climbed to the very level of our eyes and
with satanic roar
and fierce searing heat
bloomed on the air
Its roots were fed by the red
frenzy of a barn on fire

Around its base like
feverish black ants
the peasants darted in and tugged
a few desperate remnants
We could see from here that
it was vain that
nothing could be done
that hell devoured the air
Faintly we could hear
thin frantic shouts

Soon we could isolate
leaning together with their
arms about each other and their
heads brokenly bowed an
old couple frozen in
an arching arc of friends
We did not speak the tongue of
this sparse region but
we knew that with that barn below
had gone that couple's winter cattle food
their stores their tools
their very bread and
independent pride —
that as they stood their hopes
were stone

In slow-motion time
the barely visible frame
of the barn collapsed and
from a seethe of sparks outflowered
an enormous
trembling-petalled
poppy of despair
its immolating core
irradiating red into
a black expanding ring which
opened
opened into orange flame and
in a bronzed fade
died

Nothing was spoken
As we slipped in gear
we each knew
that with that couple there below
we had stared into
the utterly consuming
beautiful
cruel desolation of black
the ultimate dark heart

1971

39

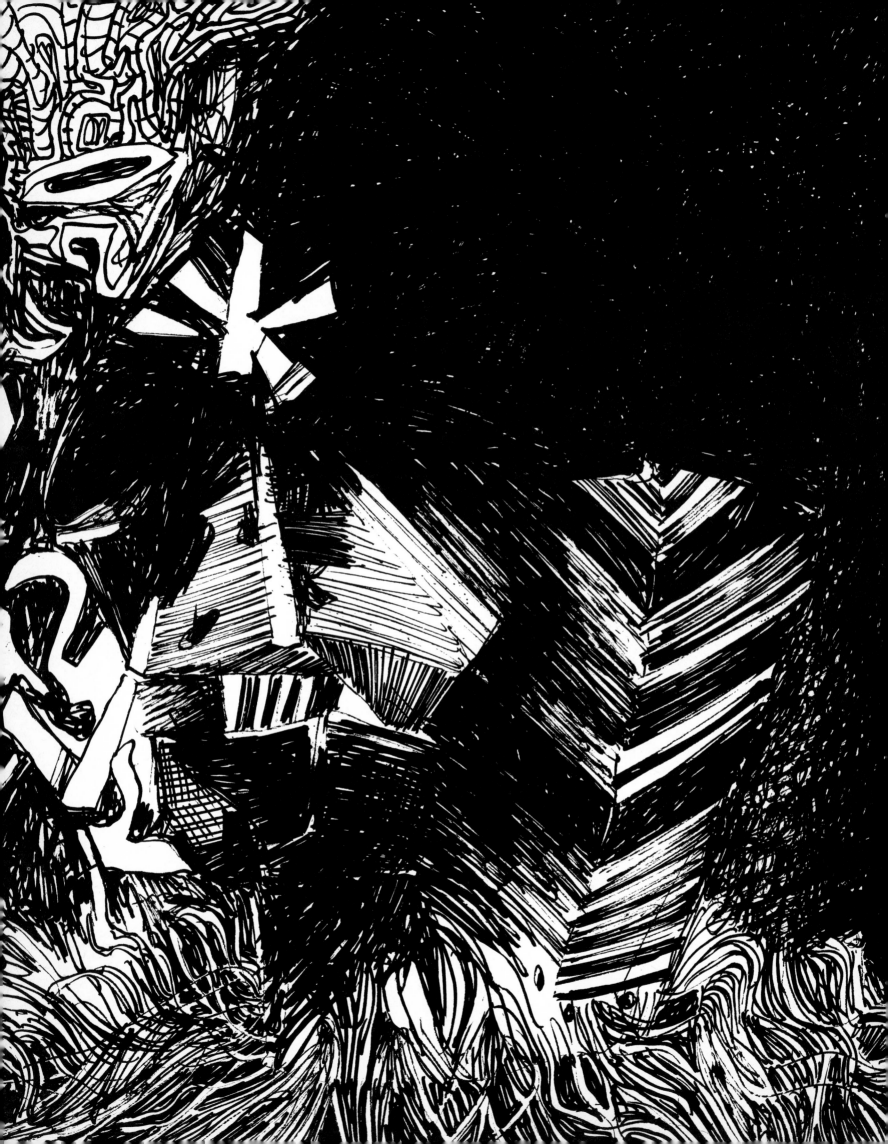

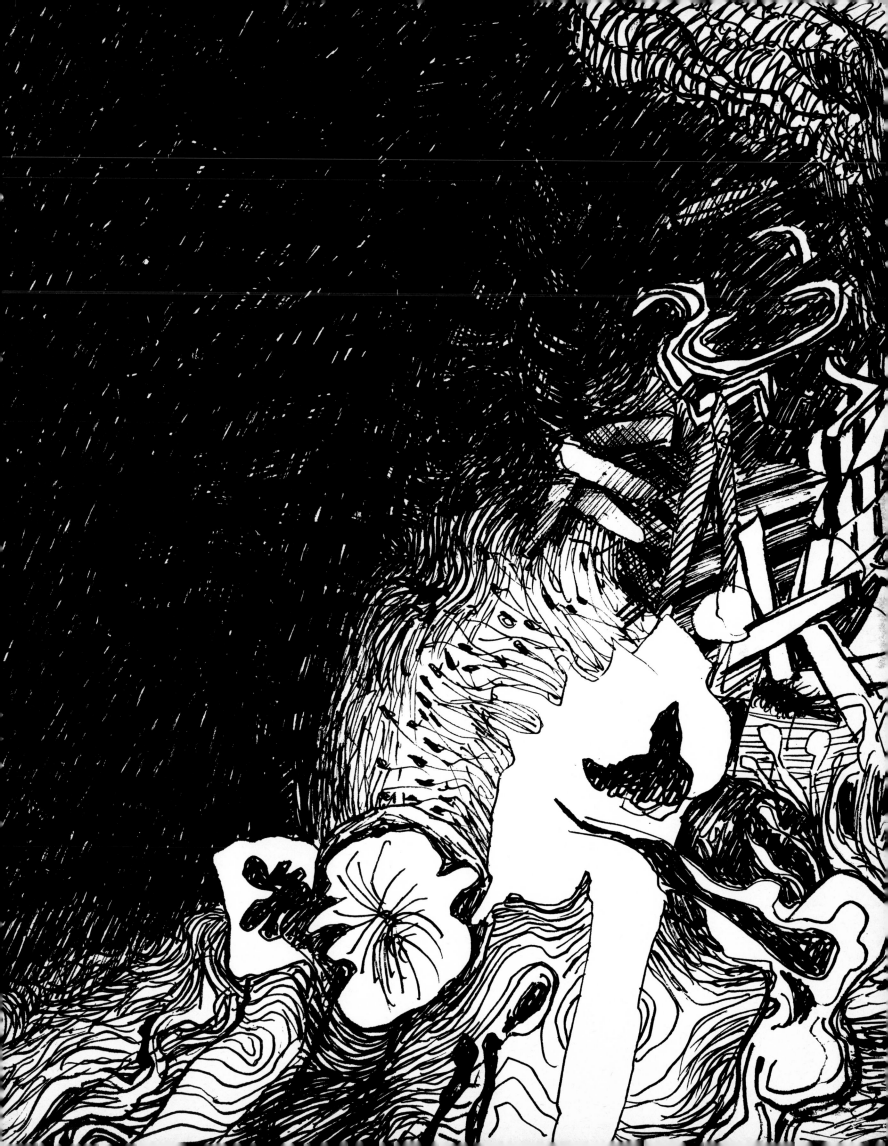

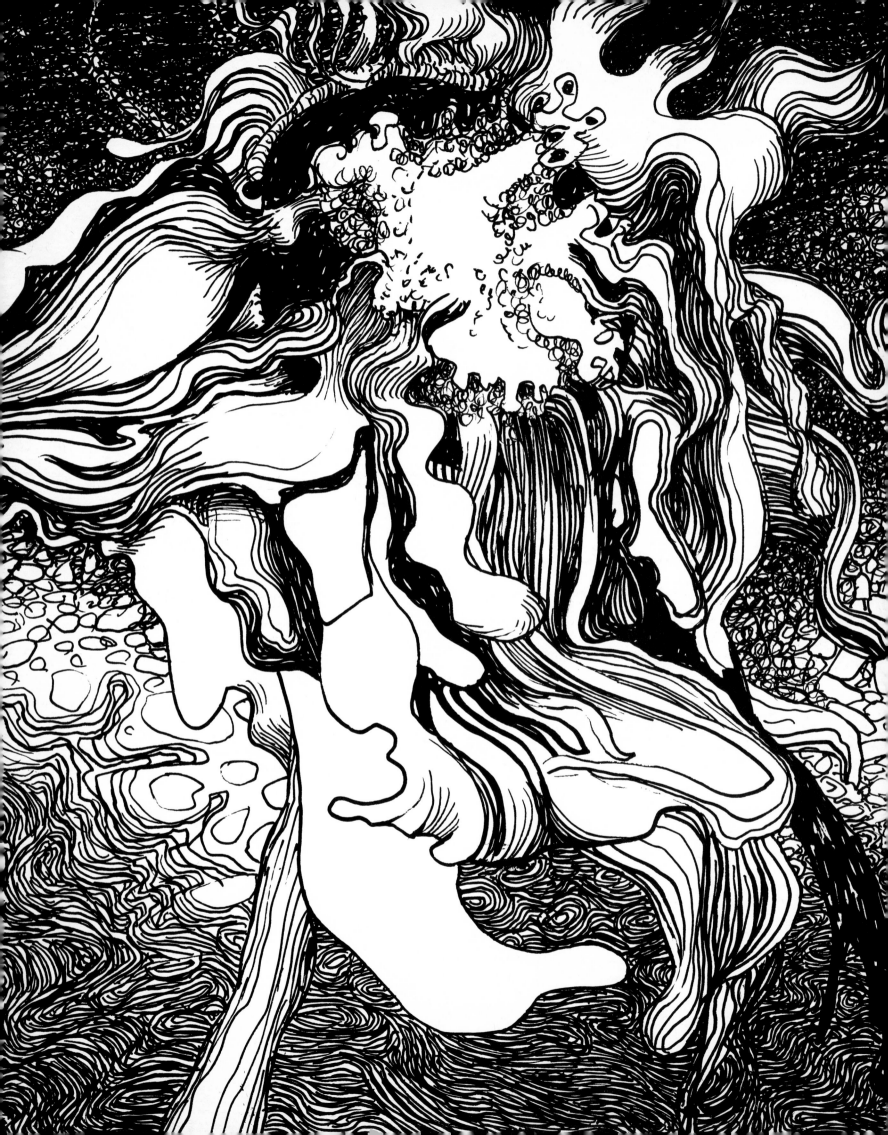

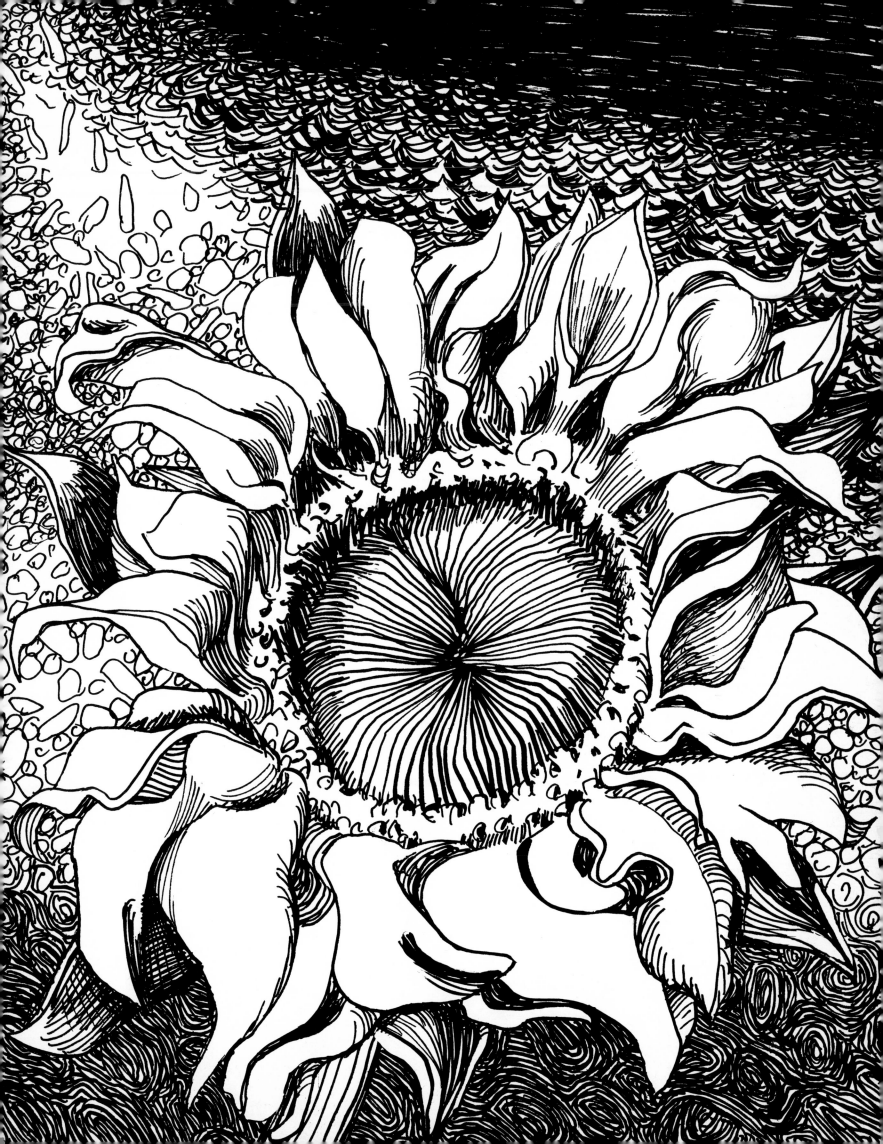

Martyr

When in parade of state
they masquerade their crime
and with elaborate ritual
commend me to earth's arms
they think from that embrace
there shall be no escape
In that grim box they say
he cannot long withhold
against the inquisitive worm
the intrepid slime
and the caress of mould
until that crib endures
no longer and the earth
falls with its obliterating weight
and crushing cold

I doubt that I can last
With vicious cunning
they have savaged me
to that rebellious line
where breath indrawn is life
exhaled beyond is death
Though they shall quell this breath
they shall not see
my stiff spirit break

Do they not see
by that one fatal breath
they render me not terminal in death
but what I gave to life?
that they will sanctify my words
and thus I shall deny
the ultimate privilege
to those white maggots
which consume the jellied eye
and private parts devour
as they scour that crawling vault
but find me never

Essence that is me
whatever residue burns still
from my persistent will
freed then from flesh
from what I did or what I ate
is incandescent as a coal
As fire spreads underground
whenever men shall tread
the earth which bears ny name
flame will burst
words will flame

1935

Exile's Grave

In steel dawn
when frost rudes the ground
under the diamond eyes
I am alive
This earth remembers me
these rocks know me
Hopes buried
heart stone
I was one with them
bone beside bone
I knew their last secret
having in time
and in place
communed

Let this earth then
witness my putrefaction
Worm have his festival
Stone crush to dust
the scavenged limb
When that last outward vestige
the precise dry dust of me
is blown
as the perpetual musk
keeps potency forever
I shall bloom
in bleak hearts

There will be exhumed
from my plot then
beyond corruptive stench
or ultimate withering
what some long wanderer
returning here will know
who has the exile's hope
the tremble words cannot account
shaped of the reasoning breath
but recognition in the bone
that here some stern spirit perished
only to flower
who had watched dumb
faith's crumbling mountains
known the bowels of grief
the aloneness
with the earth

I am a voice beneath these tombs
an exhalation from the exact loam
speaking to those
whose original will
bends them to solitude
to exiles
whispering of home
In their diamond eyes
In their steel dawn
I am alive

1935

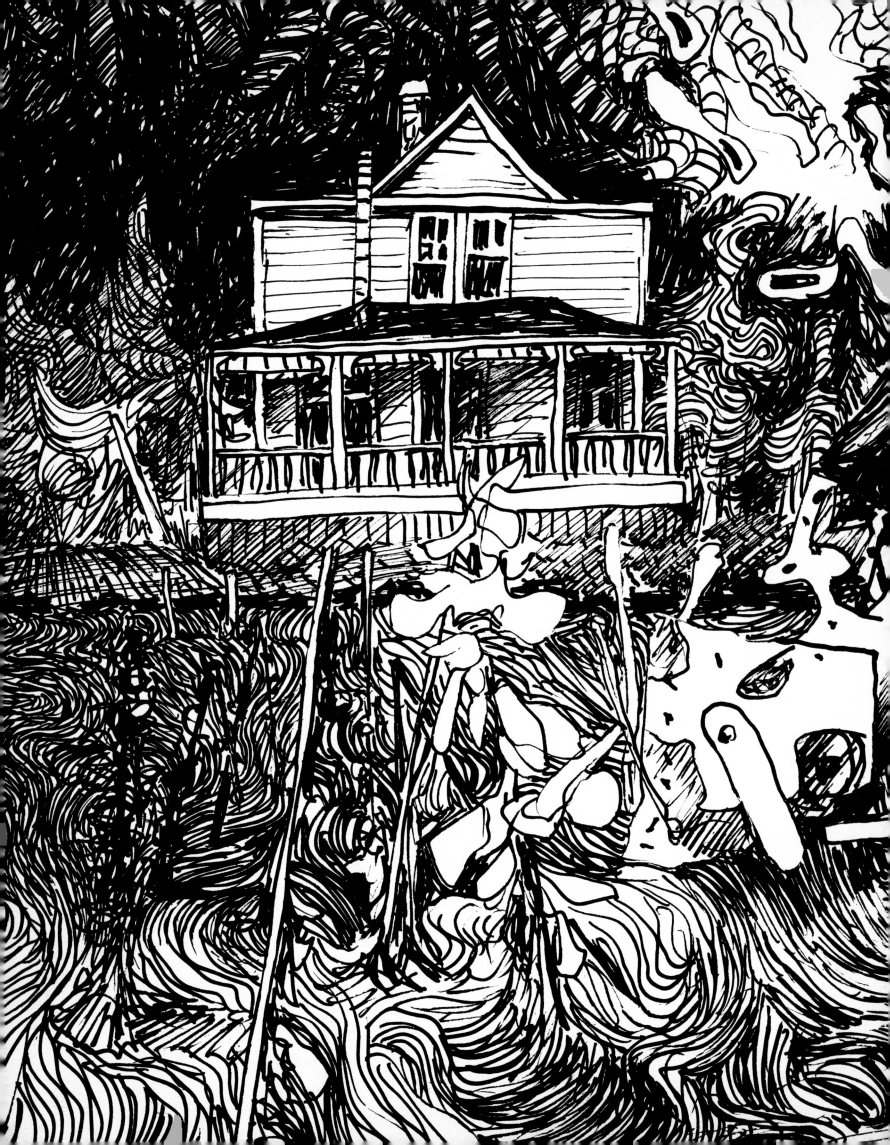

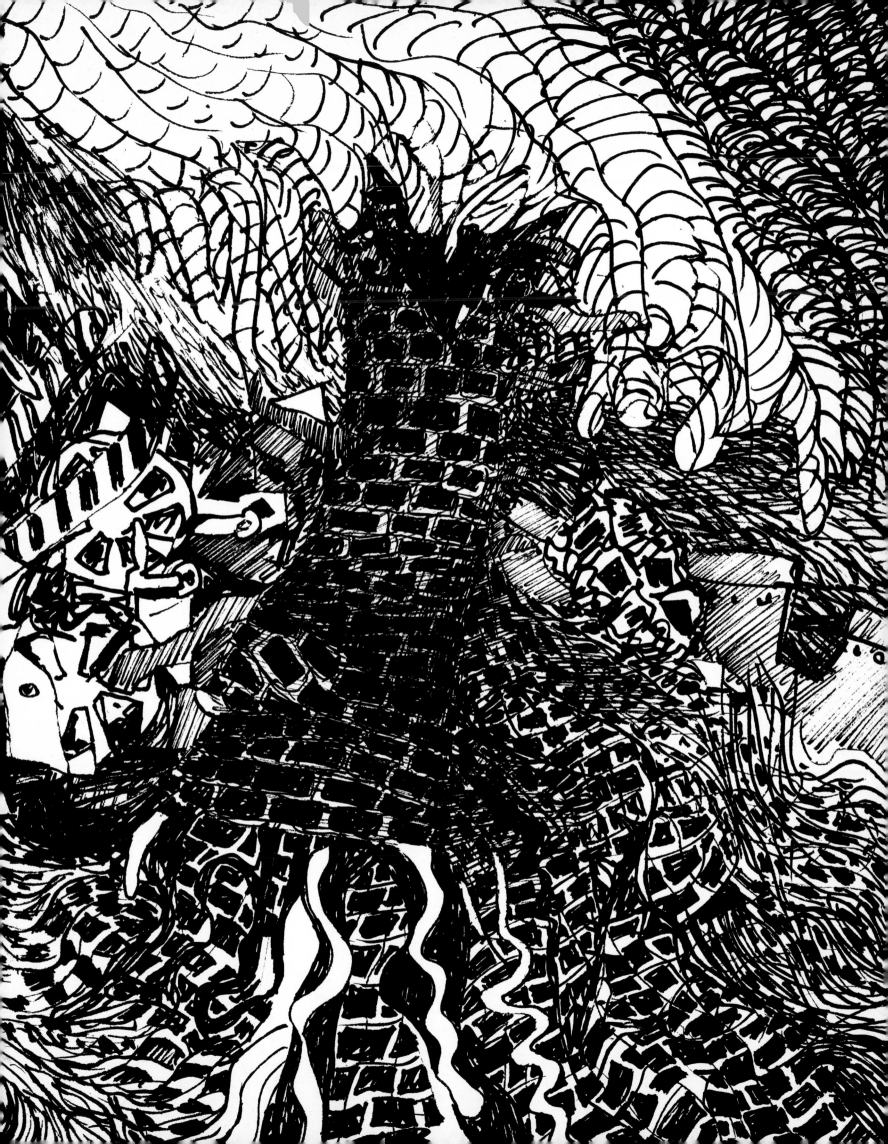

Metchosin

Across these stubbled fields
the oak woods and the snake fence
are the same

Outwardly the same
the rolling vista over
the nearest farm
the low white barn
against the Sooke Hills
briared hedges and
the gravel road
The fields behind the house
slope downward to the edge

These were the gold-grained fields
whose memory fretted
the long years of trying to forget
this land of sweet yield
with the plow's ridge wheeling
clear to the sea
followed by gulls' screaming
the white lips of the foam
silently sighing

Probably when the rain moves off
the rooks will scold the same
and the loud larks sing
into the high blue grooves
and in the Fall perhaps
once more there could be
stump fires on the headland
red against the bruised purpling sea

The house is shoddy now
it could do for a time
The barn needs some repair
Dad was the last survivor
I could bear now
to chuck it all
but as for shutting out?
Somehow I doubt
I could forget the acid years
for you could lock
bolt, bastion
seal, forbid
it would seep in —
cancer of bittered love
the eaten heart

But oh that aching roll
down field and over
to the slow grey crumpling of the bay
threshing those silvered logs
the oak groves gyrating
out to meet the rocks
in the late breeze — these
could be a start

Could it be the brine
in my streaming eyes
as here on the back porch again
hidden from the road
between painful sobs
I shed my unashamed
salt tears?

1938

48

Sea Island

War's breaking of bonds
the hard decision of allegiances
Summer is no help
she holds time enthralled
and Fall will not yet
clinch the iron change

Mad gibbon laughter in the land
chattering of apes
yet peace rocks these poplars
light air is clear
earth beneath the heel
is hard and dry
summer trembles against sky
grass is sere

This is no period of the year merely
Nations default
honour is sold

Across the tawny flats
the airport basks
A winged glinting menace
drones into the huge blue
Wasp of anger
it leaves the fishing fleet
the turbid river
for enemy zones

1942

Quarry

In this quarry where were hewn
dimensions of our dreams
whose planes carved the sky
the stone-saw's harsh chant
bespoke wide highways
to white cities
clean in the mind
the slabs of Thebes or Babylon

Sharp across these pines
the finches call
clear to that far wall where
mind is crushed now
against that tangled rim
where hawks rule
their cruel kingdom

Then
on great wings
in sun's day fantasy
the Roc
with a carcass of diamonds
Now
these looming walls descend only
to dim zones
where bluebirds
hover dark pools

1943

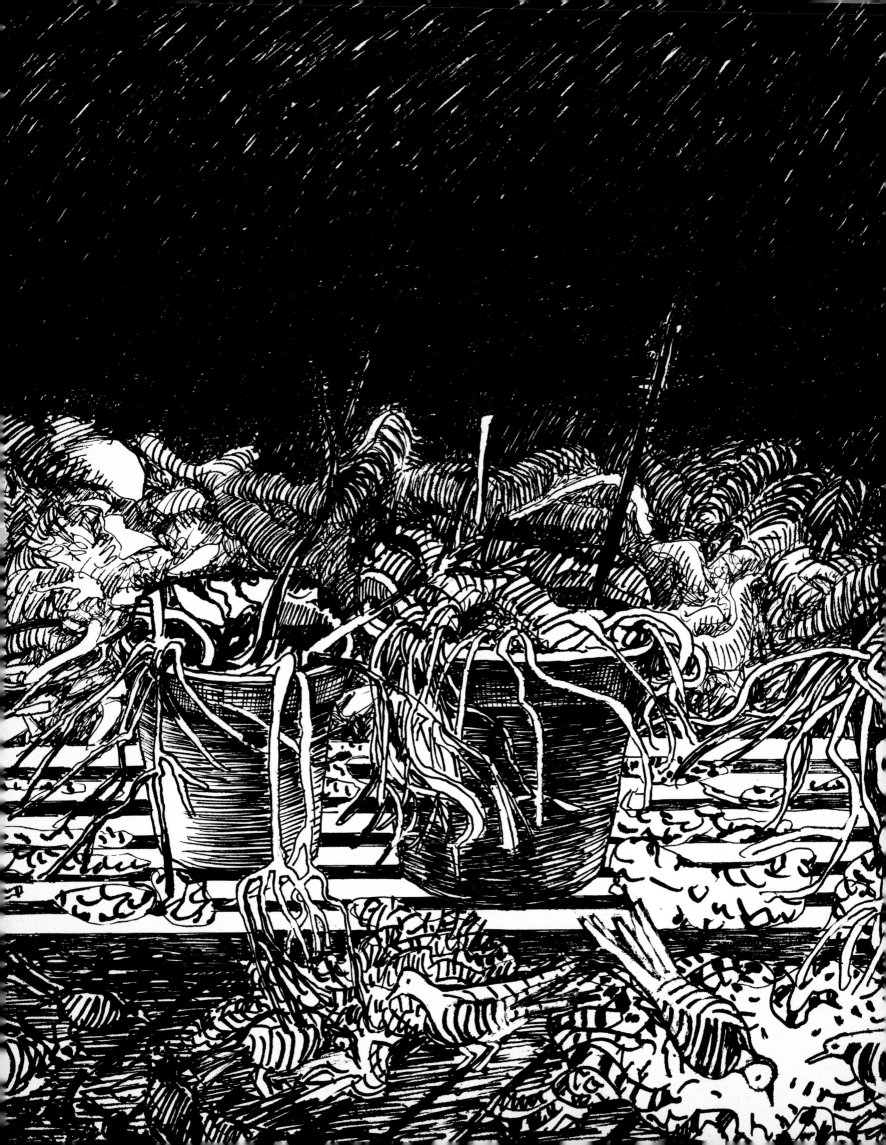

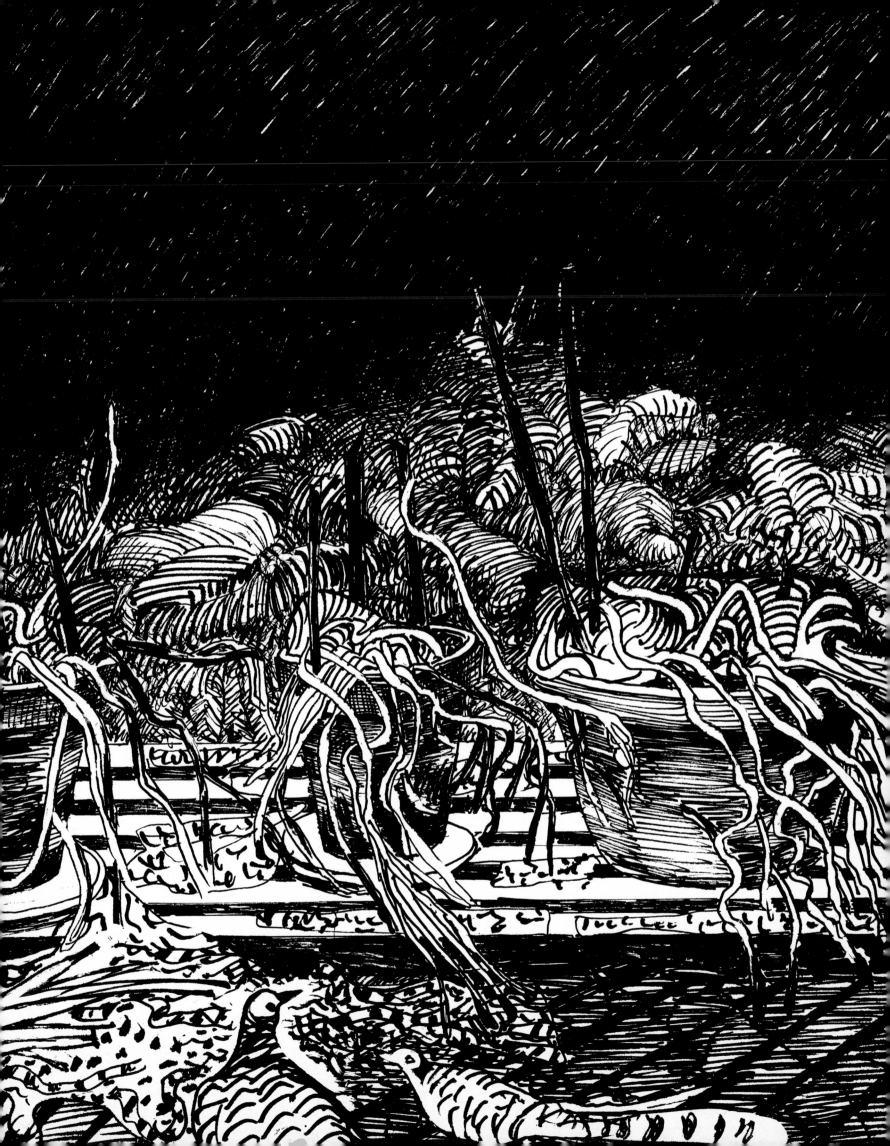

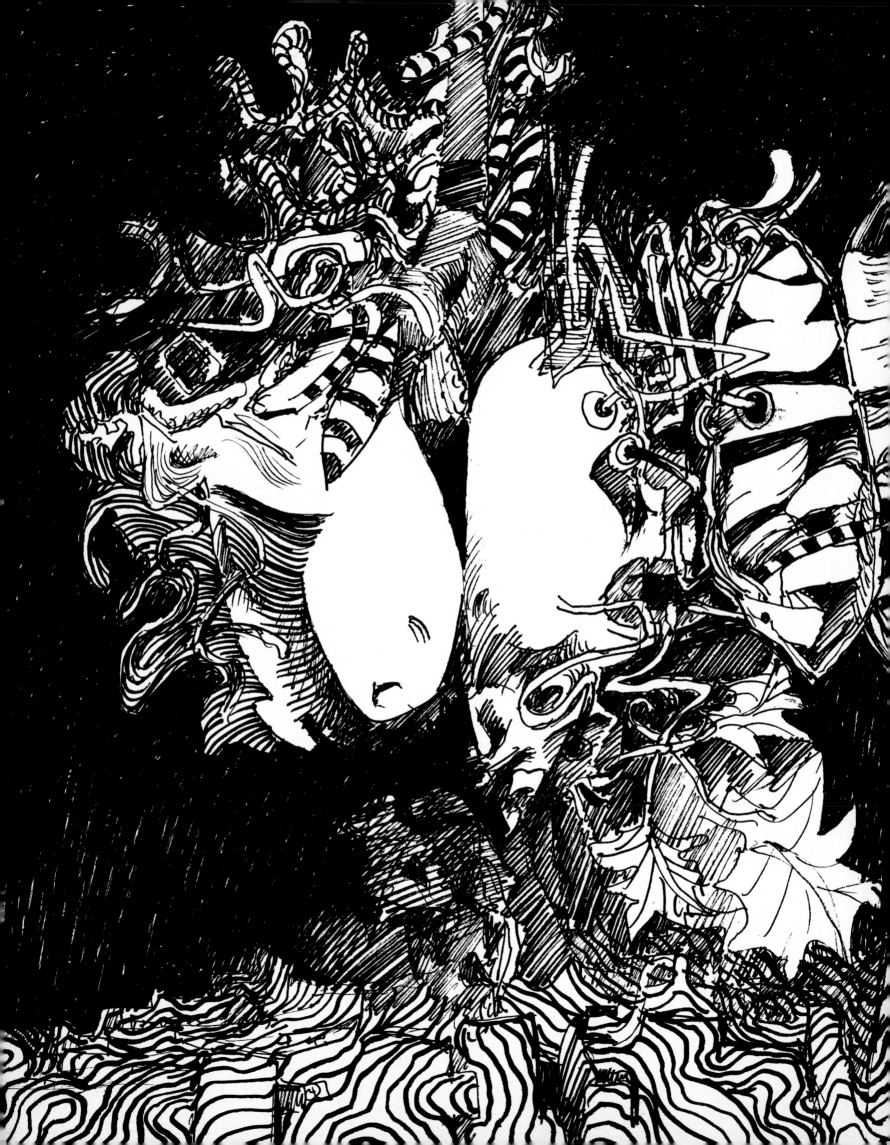

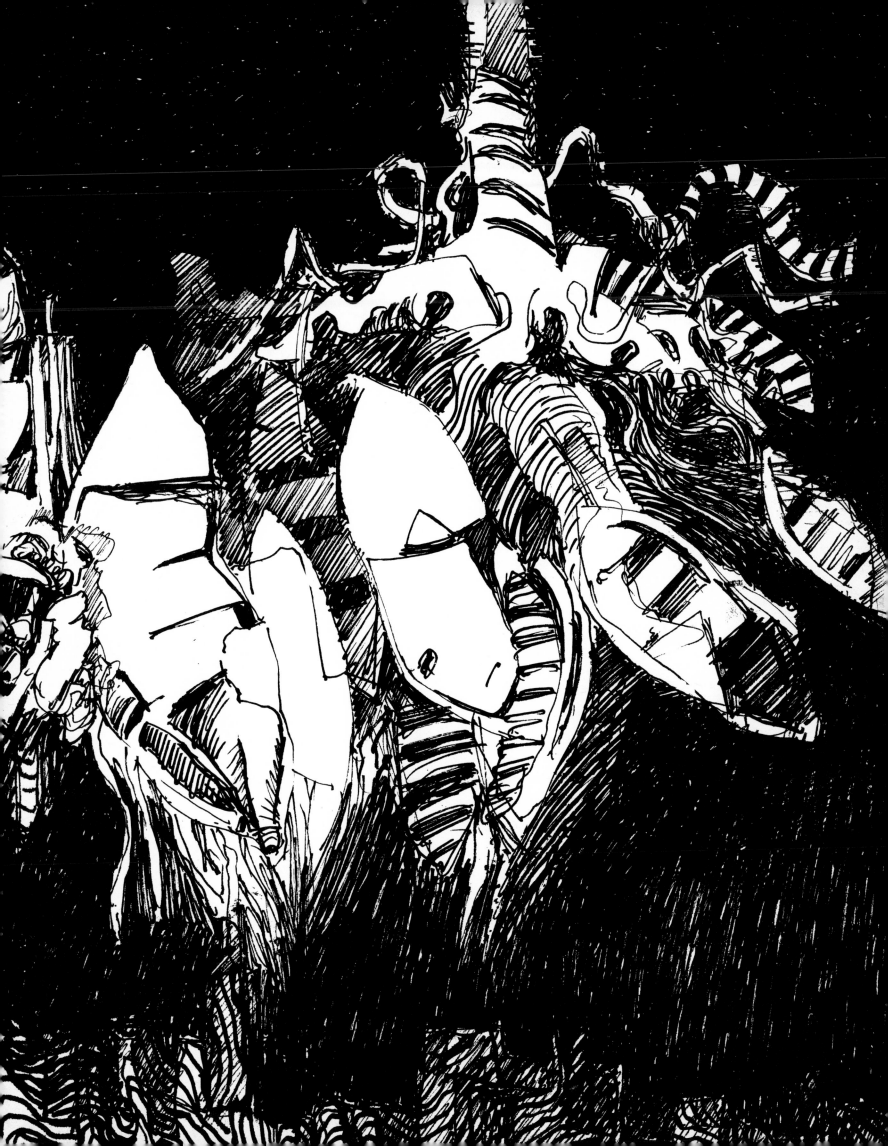

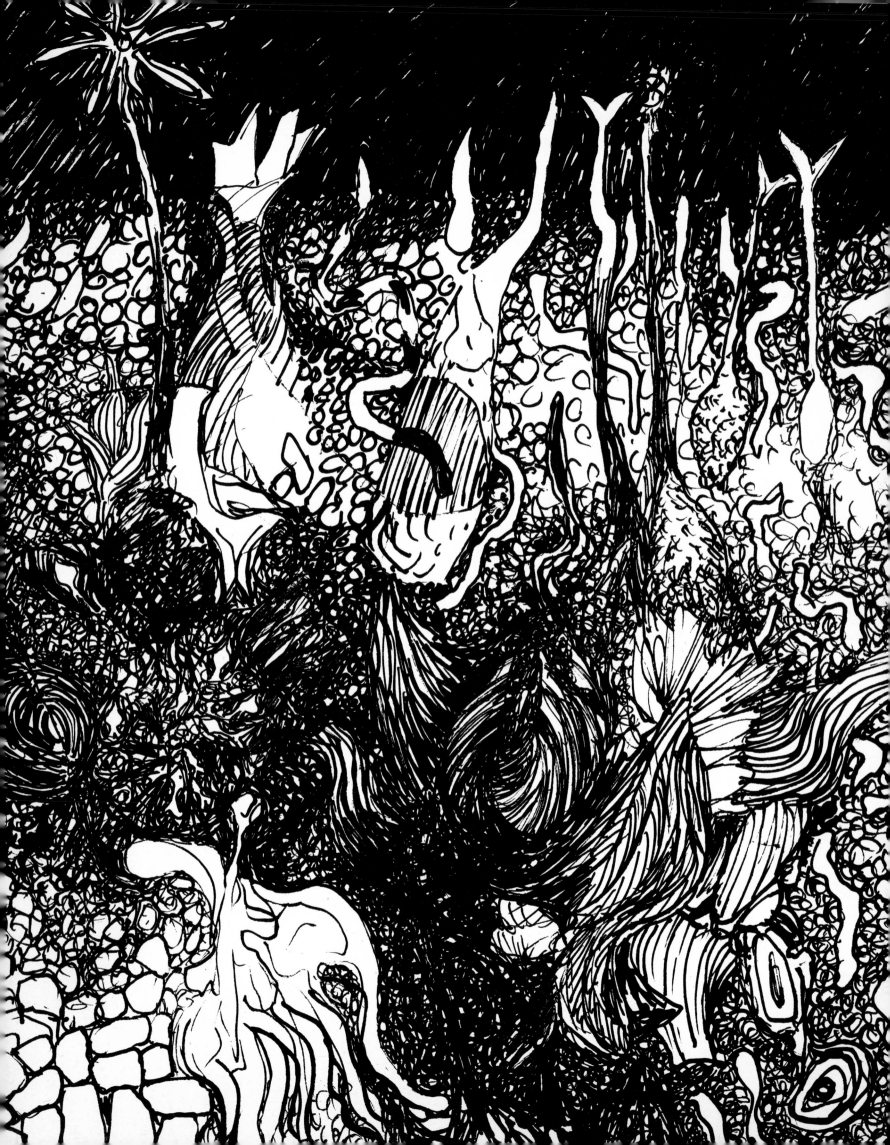

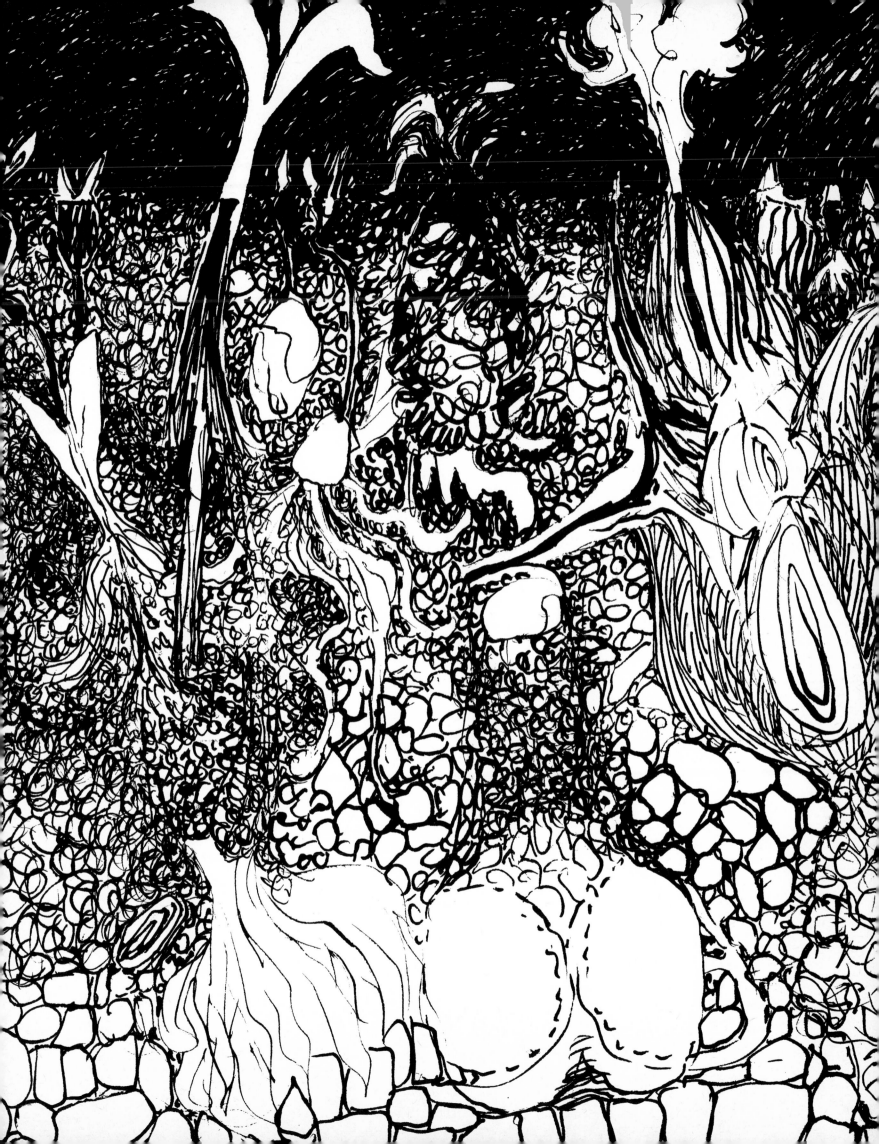

The Defenders

On our impregnable parapets
which we have built with giant care
when clouds are dreaming in the moat
and frogs commence their noon chorale
when watchers on the outer towers
are weary of the long alert
and sick of the stale food
across the aging stones
a far-off trumpet calls
This is the enemy

A sentry, falcon keen, springs to the wall
and peers far down the hill
scanning the intense fields
the burgeoning of green forest
and away, away, some glittering stream
Is it armour among the trees?
But all deceptively is still
And then we will smile and chaff
and say it is nothing

Yet we are warned
Beyond what sentinel can see or ear hear
are ten thousand bowmen silver-horned
with flags unfurled on bright spears
vast forces of white helmets
neighing of stallions
with tasselled baldrics quivering

Beneath a camouflage of leaves
when silent couriers have told
the castle's garrison is drowsy with the sun
under the disarming barrage
of innocent bird songs
this phantom host will sweep
like a great nacreous tide
over the fields and waiting unseen
in the incredulous dream
now loud at the moat's edge
will launch a rain of invisible arrows
keen against the heart
Spring will cut the drawbridge
urge the barbican and surge
all up inside those strong walls
and utterly vanquish the defenders

1950

Flowers in a Window

I watch you at the window
gazing quietly out
at the grey rain
You stand by that bouquet
lost in the scent of flowers
thinking:—

"How one is aware of the
inestimable pathos of
these flowers where you
have set them in the window by the rain
How sharply then one comprehends
that flowers are personal that they
have inescapable contemporaneity
Forever their fragility
hovers at the edge of dying
bringing perilously alive
some thing someone remembered
How these slenderest
concisely architectured stems
induce a shuddering at
brittle reality
The poignant redolence of
these flowers evokes a querulous
nostalgia for lost springs
things that have gone
youth and chivalry
deep-scented burial in blue-belled fields
the primrose and the briar and
the full inhaling of the
balm of Gilead in the valley
and the lilacs of
a certain unbearable summer"

Gentlest of creatures
how I know your thoughts
the unicorn's sharp-bitted rearing
now in vain
The rain gently falls
Mindlessly
you crush your palms
reach for a cigarette
A match
A sputtering of flame

1938

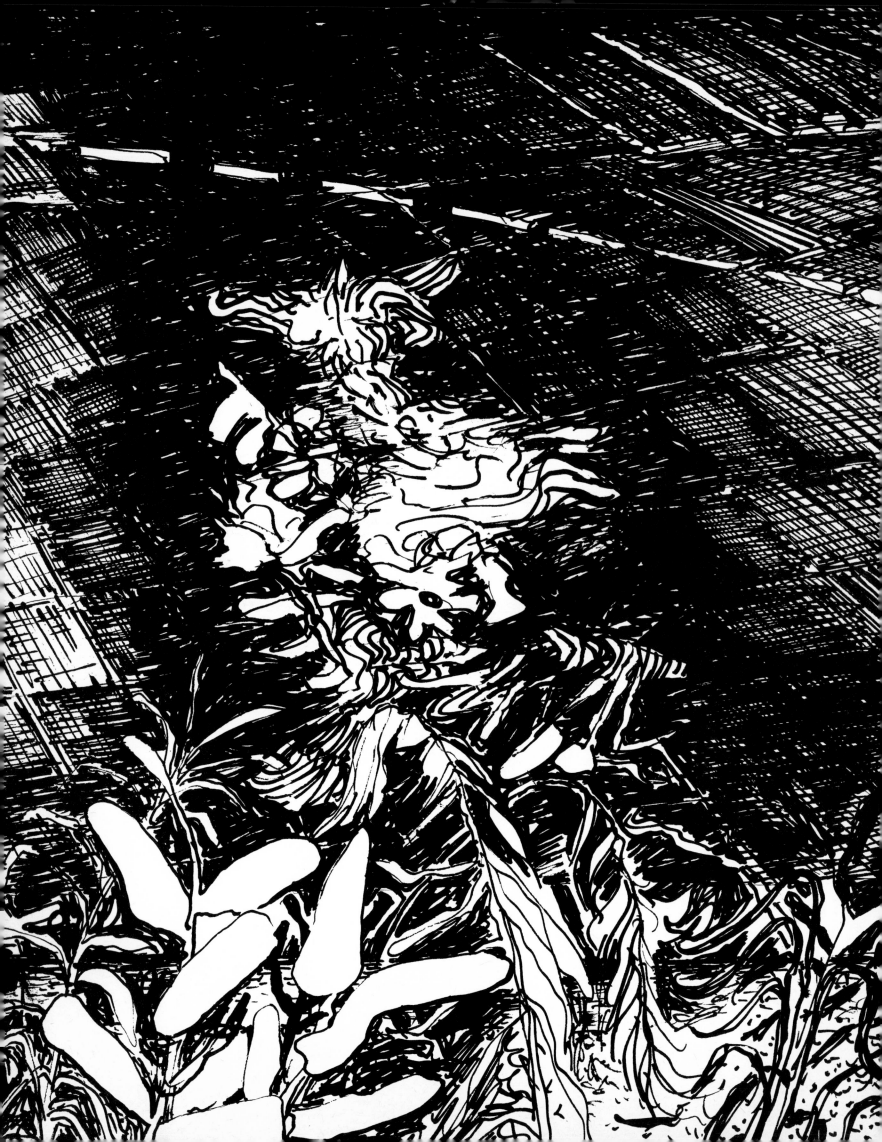

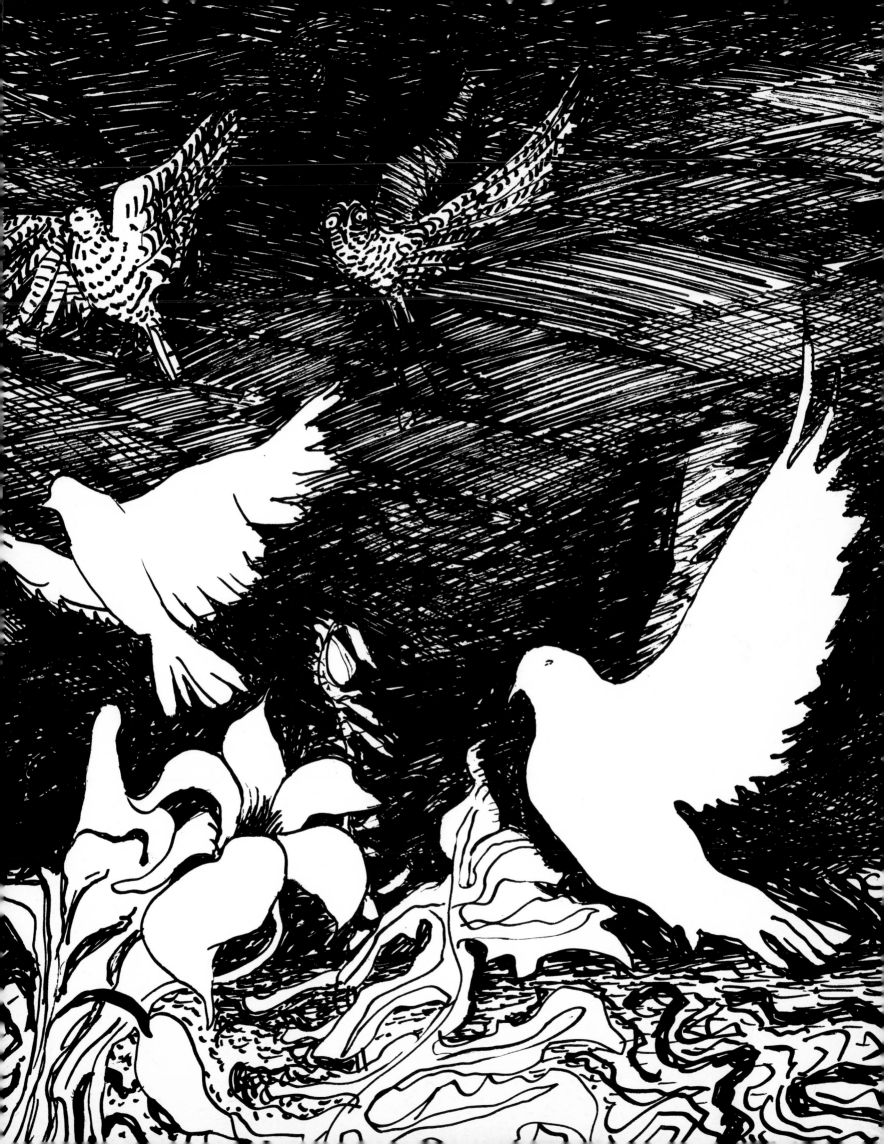

Spring Rain

Solve me this swift intangible

At red rainwater bowl
quick brown birds preen
splashing rain-blades
Canterbury bells white bobbling
Virgin evergreens ecstatic
Breeze, trees, rain

Hard-hack shiningly
waves emerald and pink signals
Spike-tipped bramble roses
tossed to wind's lash
seethe in gay
surge and surrender

Rain, breeze, trees
old garden the same — but oh
parrot poppies flash and
blue cornflowers blaze
amazed drenched freshness
Never such rinsed raingold gleams
sparked heart ever

After a winter of crows
you laughed with me today
and the Spring water-dream
brims its relief over
burbling wet songs
and flashed wings of swallows

Rain breeze trees
the old garden
the same but oh
the wet warm thrash
The poppies flash
and the blue cornflowers
blaze with potential tomorrows
Never such drenched
freshness as these rinsed
rain-gold gleams
sparked the heart ever

After a winter of crows
You laughed again today
And the spring water-dream
brims its relief over
burbling with wet songs
and the flashed wings
of swallows

1935

Morning-joyful bird
cleansing the air
with keen clean song

Its echo in the ear
rings down memory
like the silver call
across the snow
from house to barn
for breakfast
on the farm
when I was
morning-joyful young

1970

Anniversary

The fresh anemones
(our small extravagance)
are in a sea-green battery jar
against the snow
The windowed woods
stand in a white dream
The road is sealed
The world is a far country
Yesterday's safari into town
is but a faded market memory
The here and now of us
together in this room
is real

Both are gently flushed
I from chopping wood
you from the stove
Our private celebration of that year
when you and I decided we must reach
the depth and breadth of each
the other's mystery
gives to our little moment now
the roasted chicken
and the darkling wine
the torte and the sweet liqueur
and coffee mugs
before the orange fire
an air of ritual joy
of radiance and peace
I have not known
since I was a big-boned
white-skinned
wide eyed
and very shy boy

1970

At the Alpine Lake

With backs to this same stone
we sat just so
the sky red-dark from fire glow
Now pack-strap's ease
has lent to shoulders urgent wings
and coffee in the gullet sears
and bacon and the bannock tease
the sinews sing at this rock wall
and smoke eats acid in the eyes
into the spark-strewn dark
the thought falls
these tears are not smoke-tears

With groundsheet spread
with brackens stripped
and pallet zipped
this hard earth eider to aching bone
with brave flames' poised flash
the sword-beam on the lake from fish
the hawk's hollow drone
My eyes wide and burning
turn to the dark pit's rim of trees
A jewelled star moves across the night
Wearily I am aware
this is no star
but flame-gleamed tear

1937

*

A sun-crazed lark
revved up his piercing song
and circled to assault
the very vault of heaven
in kamikaze climb

We waited in the grass
The noon sun was clear
Higher and higher yet
almost beyond ear
we waited to hear
his stop
before the immolating fall

That summer we were young
we loved like tiger cubs
all risk
all splendid strength we thought
and naturally
bodies bronzed and hair fair
Now it was time to go

We waited for that high wild lark
to falter
to descend
in flame against the sun
but the song soared
and held
and faded

We had no special gifts
as students then
no training in the sign and symbol lore
but in a sorter-kinder way
when that song had simply gone
we sensed a metaphor
Something had ended

1939

Nocturn

If this late-homing bee's
crazed mumbo-jumbo
could unbumble from the air
his roving hum
he'd find it ravishing
beyond compare with nectars
never dreamed beneath noon's sun
from rolling on these fields

If night had eyes to see
the yield of corn-silk rapture
to be gleaned
from flowing hair beside me
or could hear
the throat's sweet gurgled whispers
infinitely dear
night's eyes would dazzle at the sight
ears burn at such a molten note

Or could the dark hills turn
to moon's urgent touch
as firmly to the hand as
these two cool pippins rise
roundly and as hale as
any harvest prize
the drugged breeze
would swoon the whippoorwills
and stooks stand stiff
against the night

1936

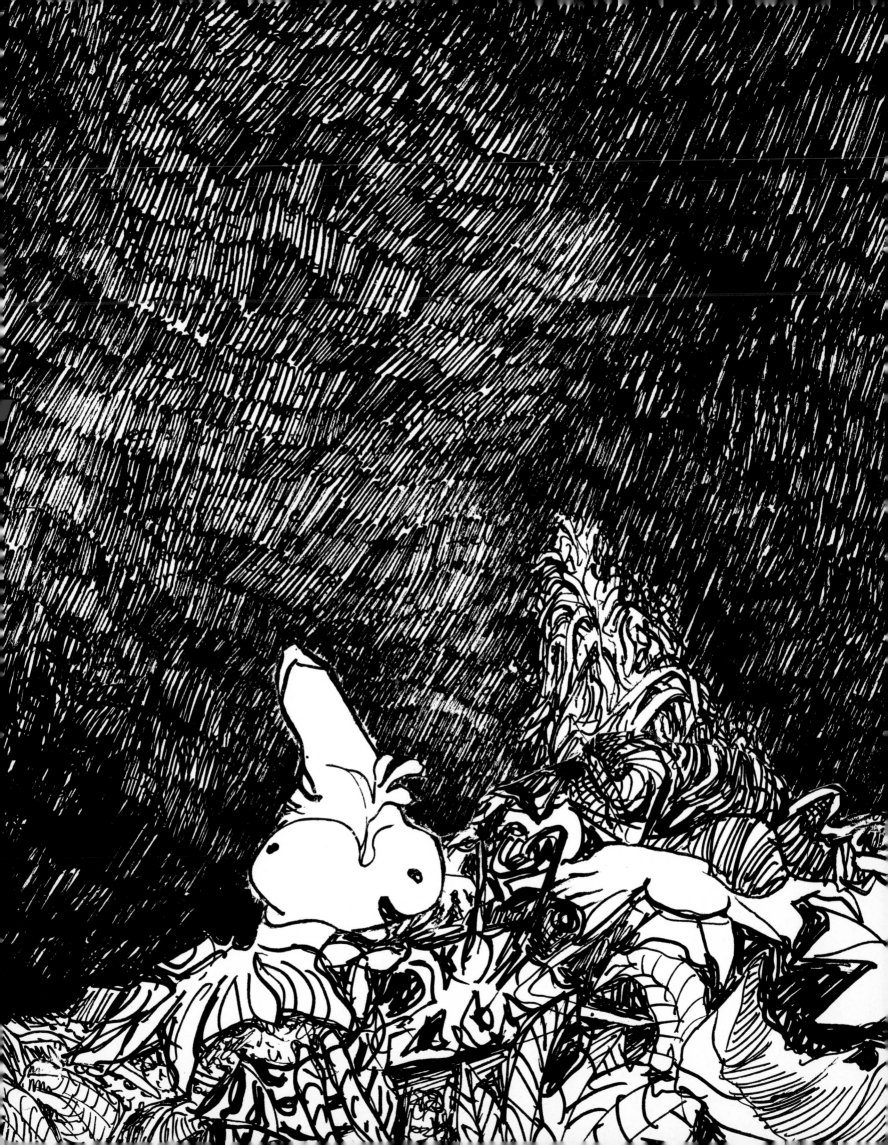

Looking Across

Each morning as I wake
my view is out across the neck of sea
toward the Island
and behind it east to west
the mainland hills
At intervals throughout the day
I pass and re-pass windows
in my measured world
from kitchen to the table to the den
and as I move my eyes will turn
in momentary lure
to seek across that water there
the fretted edge where this
our inland channel chafes the Island

Always facing me
the brooding Island
with its sombre conic evergreens
Its dark openings inward
over bending rocks
into the dim recesses of the trees
are calling me across the heads
of pink opiate poppies
just above the windowsill
and blue spurts of larkspur thrusting up
and fine tendrils of my columbines
There between and over them
along the very level
of the riffled racing water
is that beckoning mysterious rim
Behind the tide-rip's silver slag
tarnished with a moiréd shadow
is the rim of just beyond

My Island looms at times in mist
with cloud dragons walking on the hills
the grey wraiths curling and unfurling
sensuous gestures urging me to pause
and let my mind out through
the empty sockets of the blue
above its dark profile
But the Island sentinels
in solemn columned loneliness
a never-breaking phalanx form
over the involuted rocks

and the broken coves
and small jagged bluffs
protruding out around
whose winding rim
always and forever
seethes expectancy

Those white tossing forms
that rise and climb
and drop down in behind
and tumble over tumble on the rocks
are always restless there
across the sullen shreds of racing sea
across the channel
at the edge of fantasy
where urgencies are never still
the little hopes that leap
and die with sighs
the lips of anguish opening to the sky
the closing and submerging mouths
calling forever calling
of small dreams that die

Across
always across out there
trying in vain to scale
the slippery rocks
to gain a foothold
on the dark Island
always falling back
down shiningly impervious walls
yet tirelessly and ever
with a quiet joy
rolling and rolling
mocking me out there
with feigned dolphin
gestures of despair

1972

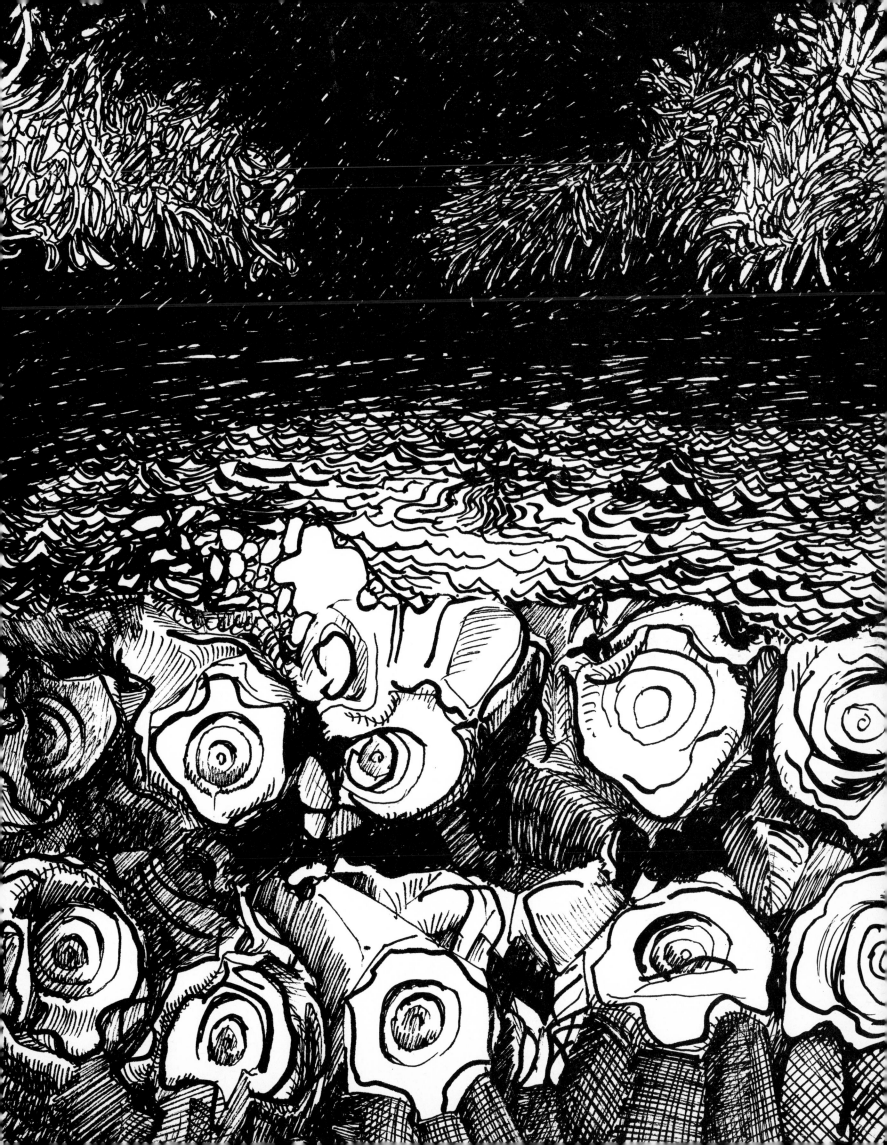

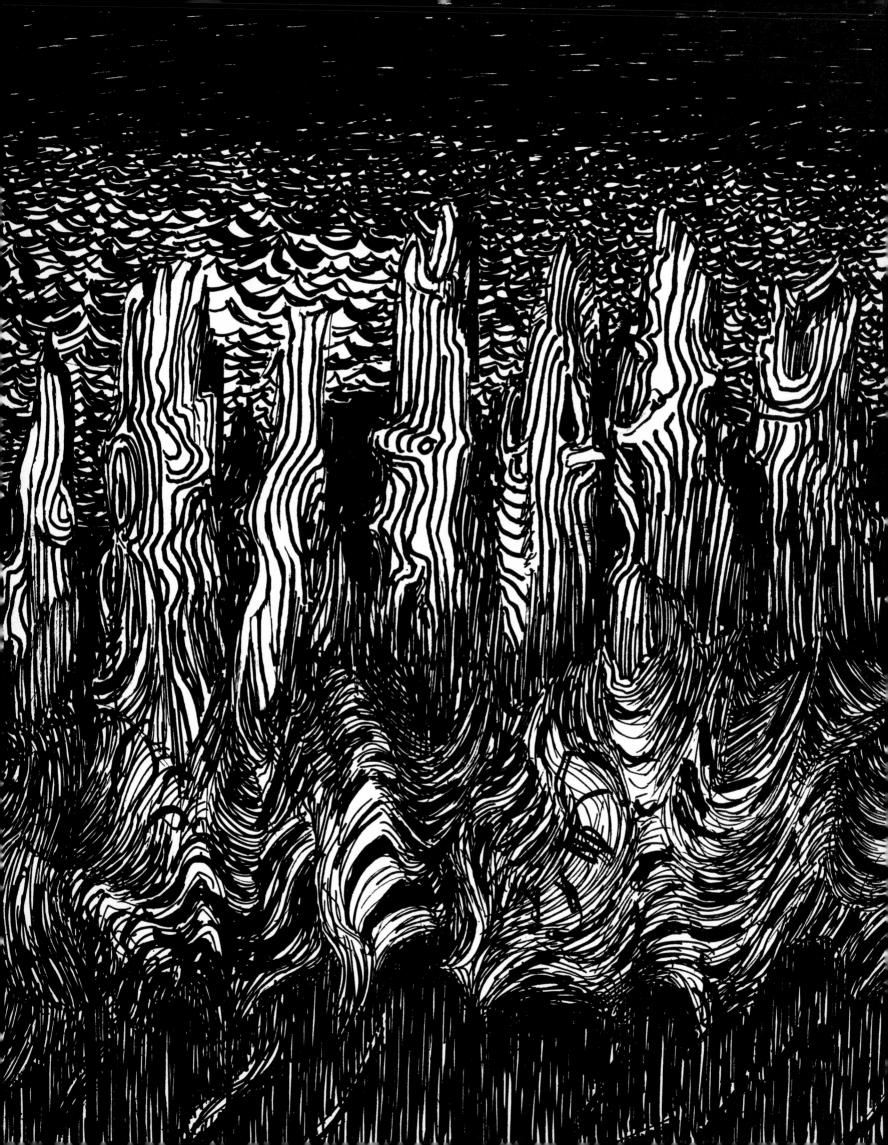

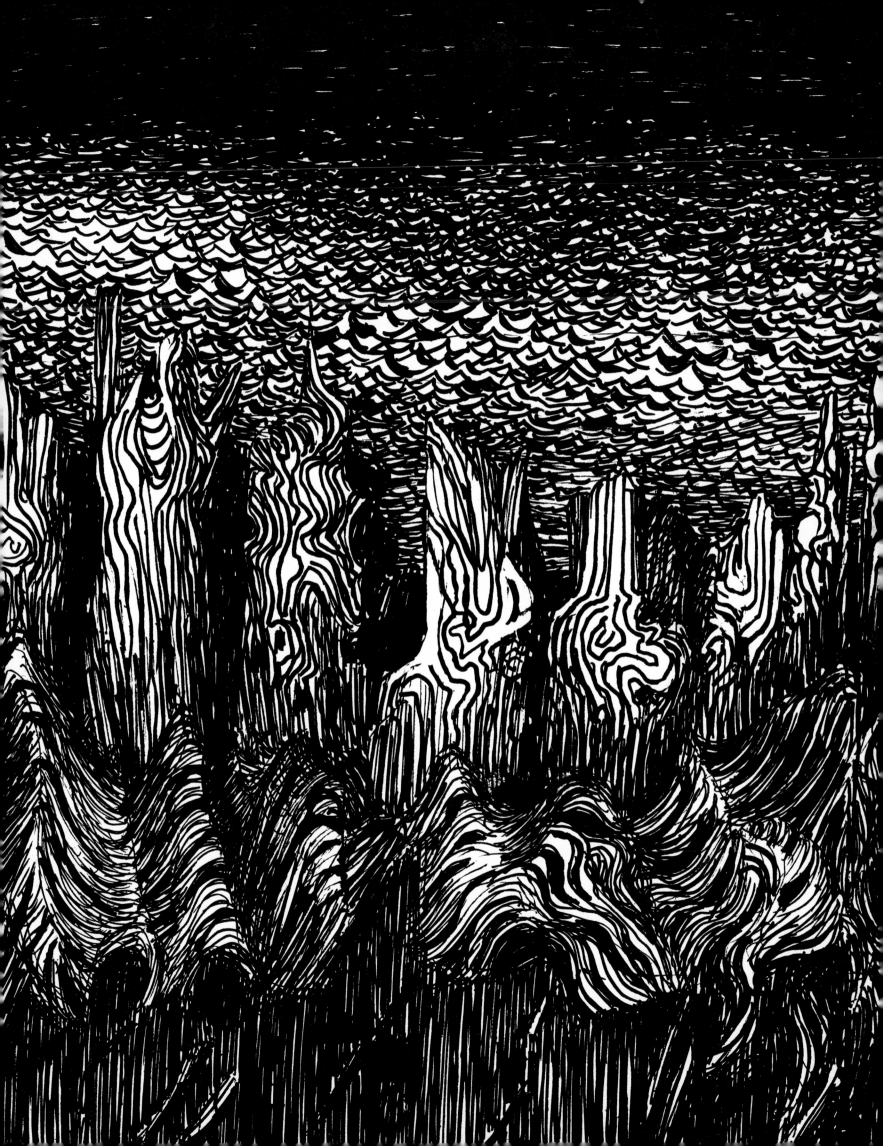

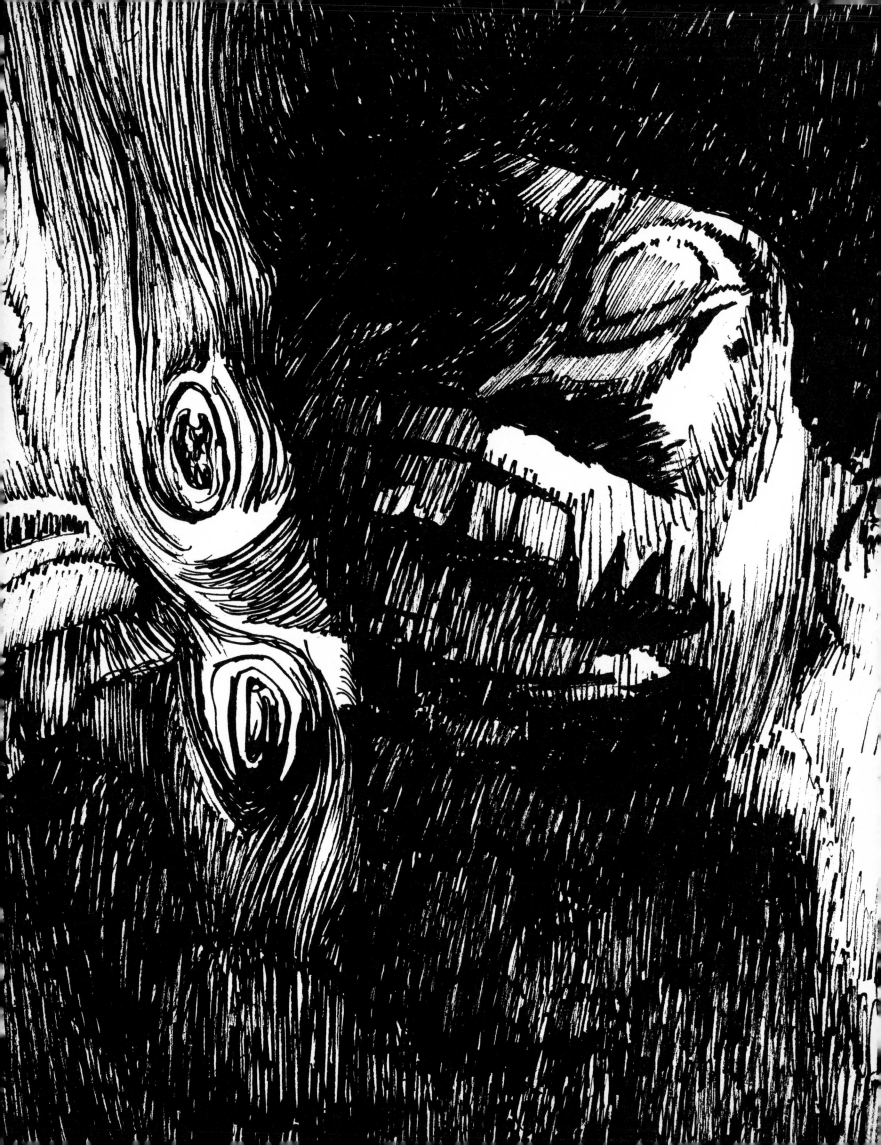

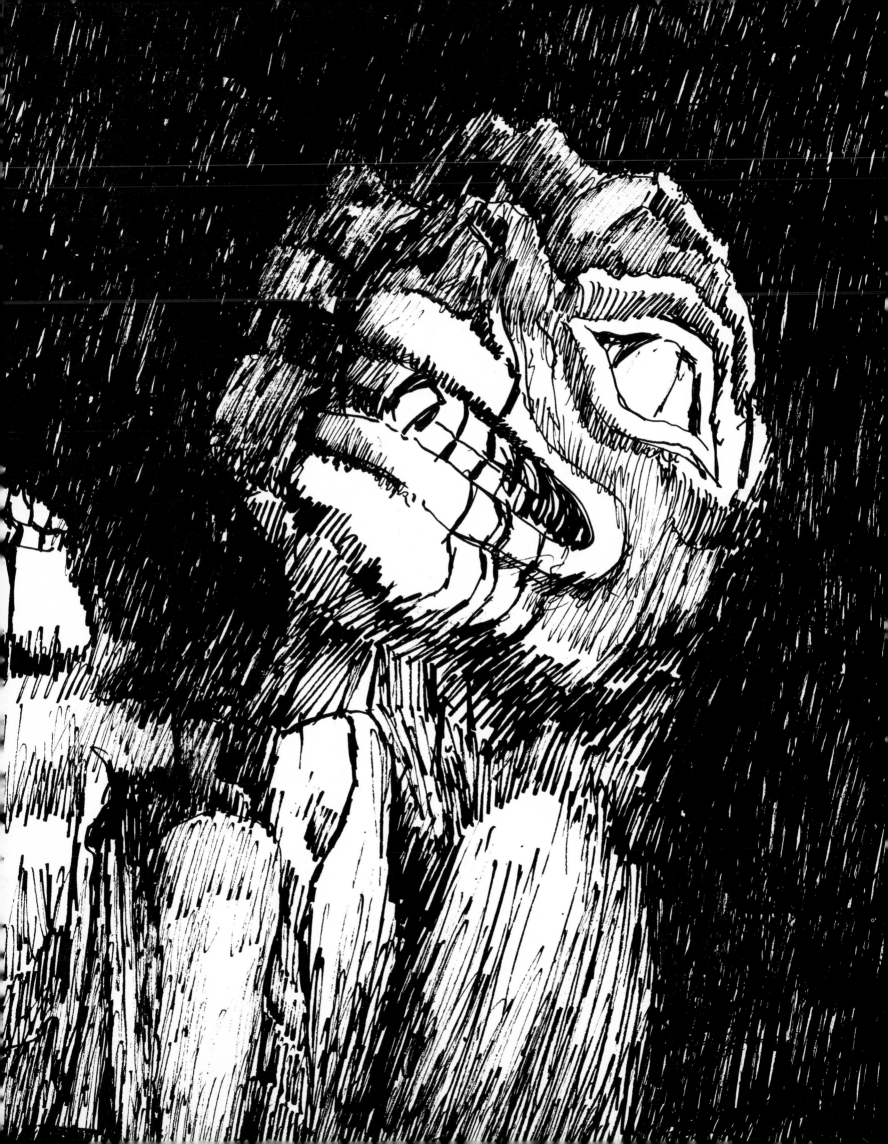

Agamemnon Channel

Intruder
though your arrowed launch
cleave burnished rind
from the steel water
look ahead at those dark slabs which
plunge to bar you
Argonaut
the channel is narrow
Agamemnon sleeps on these hills
far up the white valley
leading to the clouds
These vast cones of slag
smoke forever
Stranger
if you would penetrate these barriers
prepare for thunder
Cold invisible air
that knifes your prow
strikes warning
These are hills unassailable
that know neither night nor morning
strongholds out-towering time
ramparts of loneliness

Princess Louise Inlet

Tongueless walls
what plan to this great labyrinth?
These rude slabs world's edge up
do they dare the mind to climb
this sheer cliff to sharp brink of cloud
to cross that ledge
to regions inviolate
seeking the aged turmoil
huge melting of snows
crumpling of glaciers
grooving of hills
flumed concourse of rivers streams rills
mighty convergence
hurtling of steep heavens down
fanged waters
Should we stand and defy
shout to these adamantine walls
or cringe and pray
to these great domes
whispering to the stars?

From these immense
tragic stones
no reply
Only the thundering spume
of that tumbling great fall
with silver radial rings
trembles this film

blue heron's frightful cry

1936

Author's Reception, London

Clinking glasses in the room
The bright chattering eclat
breaks around him
but the

Cold
bouldered
fountains of his spirit
well and knock
the rock foundations of his mind
the jade embers of his eyes
bespeak the wind
the white danger

Silvery
and elegant voices
resonate with wit
and charming questions
float to him above
the low cut necks
and Ascot ties
and yet

The snarl of thunder
and charged cloud
from purposes remote and proud
are latent in his eyes
With steep glories on the tongue
his tense fervour frightens
those who for the moment brighten
Mutterings of "strange"
are eyeballed through the room
and he appears to shout alone
yet

There are those whose tone
of genuine respect
is manifest through all the interchange
but

Can he reach their tenderness
who read within his eyes
barbaric wilderness?

His publishers are kind and gay
and he is lion of the day
although his suit
is not just right
his tie is just a little bit
askew his hair
unruly gold
his gin and bitters
merely sipped
his biscuit scarcely bit

Better that he breathe
the bitterness of resinous trees
scaled of these small galls
of politesse

He *is* a trifle tall
one must admit
(his head and shoulders tower
above the room) and handsome
in a craggy sort of way
however

Better that he stand unbent
and tall in loneliness
which is with sky
and crag and beast
alike to all

And there are those who find him
genuinely fresh
a diamond in the rough
a style a bit abrupt perhaps
but then

The biting foam-teeth of the Coast
anfraginous astringent
these steep slopes alone
bright if bright
sombre if sombre
are his strength
his mountainside

1938

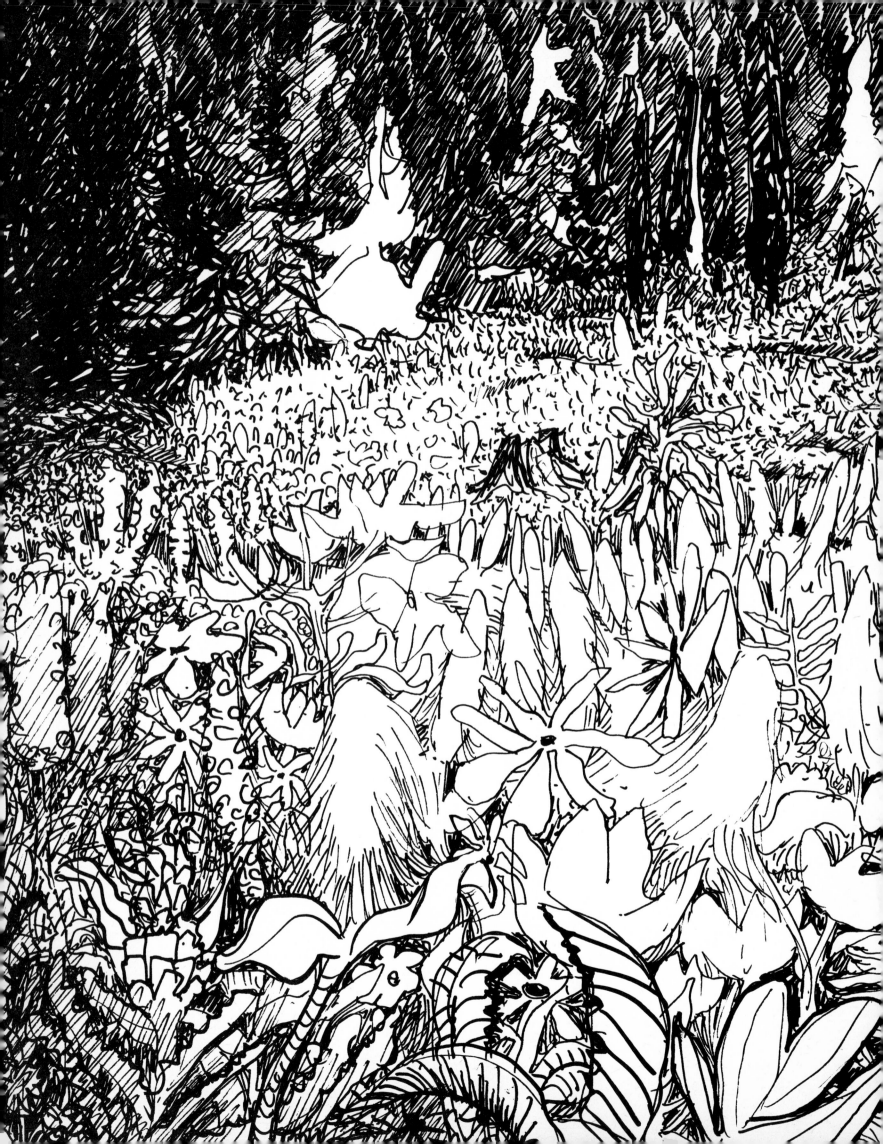

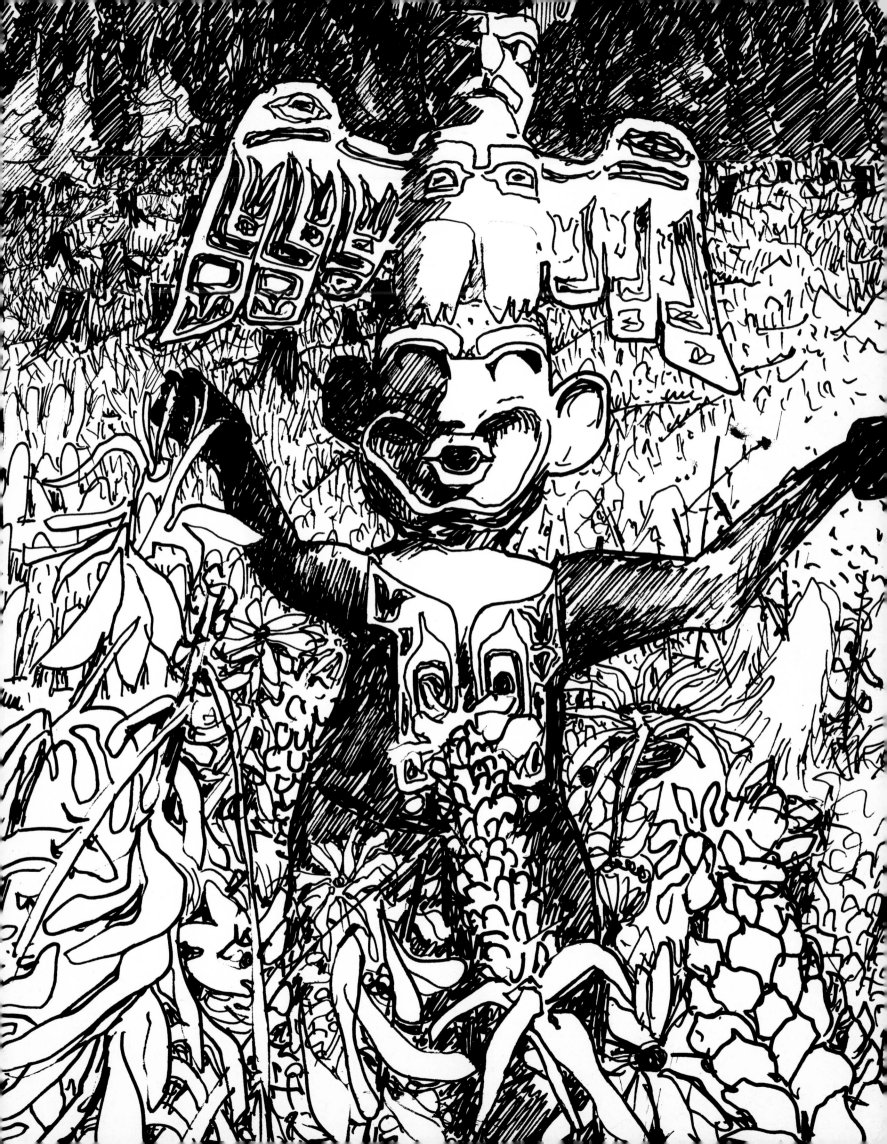

I have a wakening dream:
a voice
exquisite and as clear as memory
sings on and on
a threnody that almost I recall
yet never quite
I know it is my song
it is of islands
and of summer
rising now
now falling
holding me in thrall
unbearable almost
and yet I fear
that it will end

It is a song which
breaks like white spume
stings like salt spray
dies like the gull's cry
with rock sea and sky
emblems of epiphany

It is a cante hondo
of taut wings
above a ledge where grow
mimulus and the spiked gorse
with the sea below
in a grey roar

It is a cry
to ease my fever
into noon's dry gold
as once on these hot rocks
my heart was a cauldron
where humming bird's fierce bronze
and dragon-fly's blue ember
fused in smoulder
when she mocked
and left me
and when later from the cliff
(the song goes on)
I watched with sightless totem eyes
her launch receding
cleave its galled track
across my solitude

It wakes (the song)
like a white fire of gulls
across blue water
falls through memory
like a meadow lark's clear call
down mind's sombre corridors
to rout my winter dream
of tombed terror
and to ease
my wound's crimson flow
onto the dim grandeur
of some Siberian snow

Swift as the arrow tip which flies
from silent leaves to fell
some grey-faced monkey
screaming in the Amazon
the barbed song will pierce
the red dark dream
with exorcising red from these clean islands
poppies on the granite cliff
arbutus bark
the beach fire's glow
red sun's uprise
or dusk volcanic in the channel

Here (the song assures)
knife's gleam is only
prow's mercuric rind
across the metal bay

Fear's grey is only
grief of seas
silver of logs
the tumbled salmon sheds

White terror is
but tide's bright tears
on Moon-white sand

Summer of Days

The voice is plangent now
it calls to men
remembering lost summers
It will cauterize
yet tenderly evoke
like the shadow of smoke
across a mountainside

It will crash blaze-bright
over the mind's emerald lake
to send parched streams tumbling
down dry bouldered beds
into a fanged river at last
to pierce the withered plain
and reach the sea

It is a song
spined as the fork-pronged pine
honed as a blade and strong
as the curve of a lily is strong
to tell me
gone is the dark dream
drifting on morning air

gone is the ache
of radiant hair
of her arched throat
her liquid laughter's sear

hearing it clear
I can then bear
I am awake

1939

Honing and honing
grief's obsidian knife
the churned foam
grinds the winter beach

Brief summer days
a hollow ache
remembering from off the shore
the riffling tender grasses of
the breeze's adoration
how it fondled the gleamed leaves
and so electrically caressed
their nubile green that
whole trees shuddered in
a frenzy of love's whisper

Skin sun-tender
in a silken dream
recalling ice-green furl of
waves rolling the light body
over and over into
crazed rapture

Summer of days
you gave me streaming sands
scent-wild fields and
a charmed name
Yet you laid me naked
to the crystal edge of my despair

1971

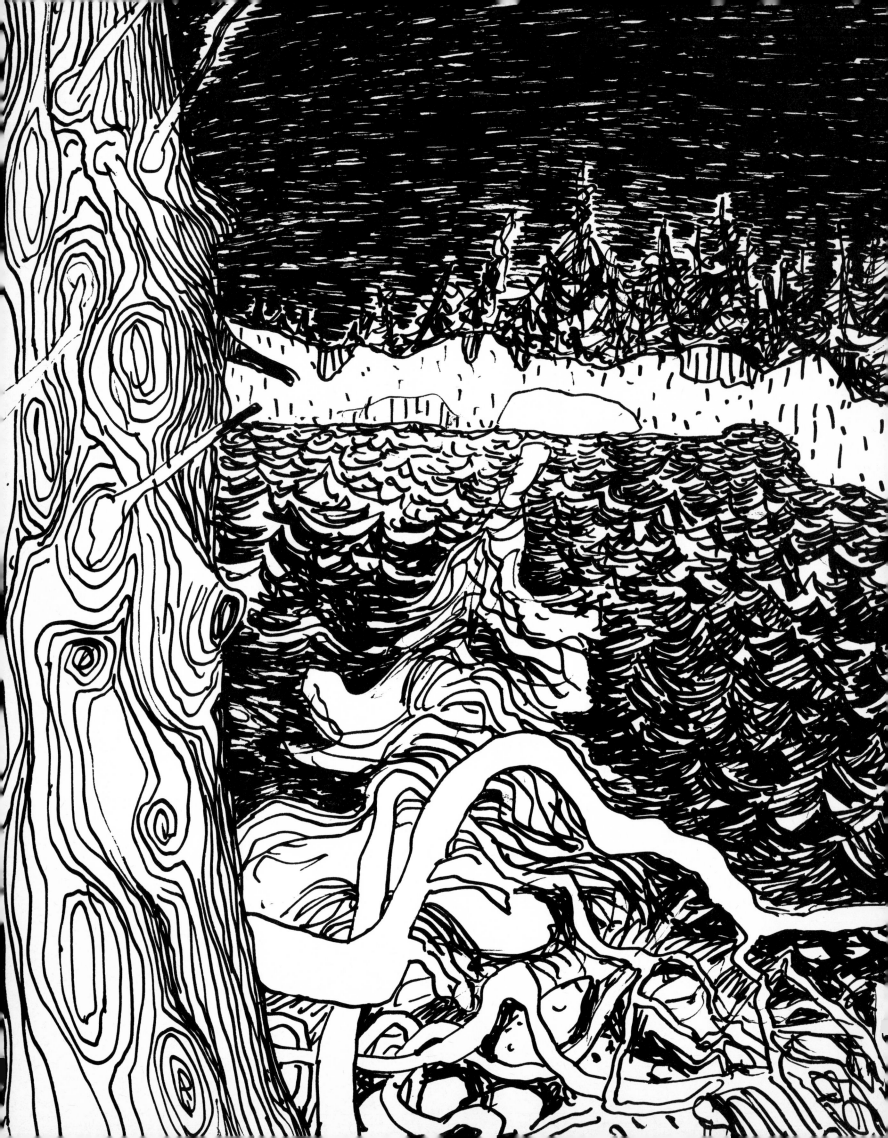

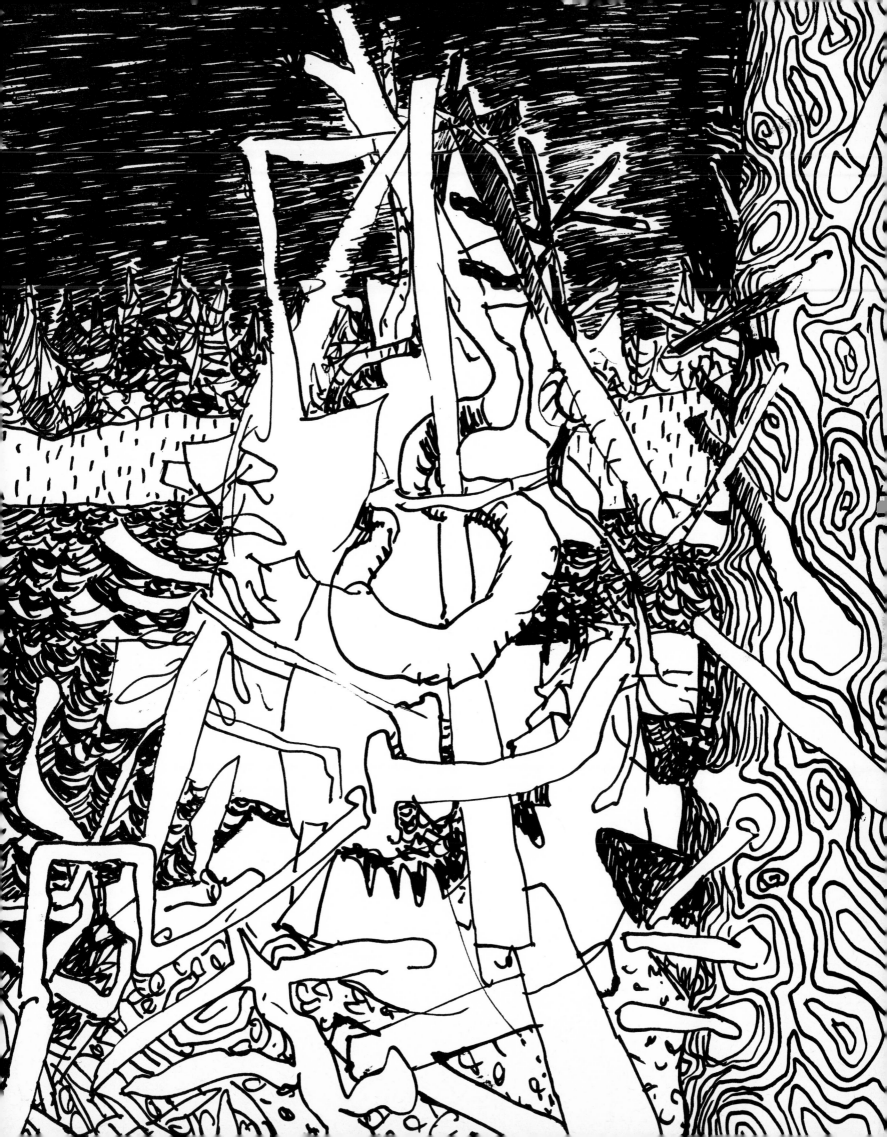

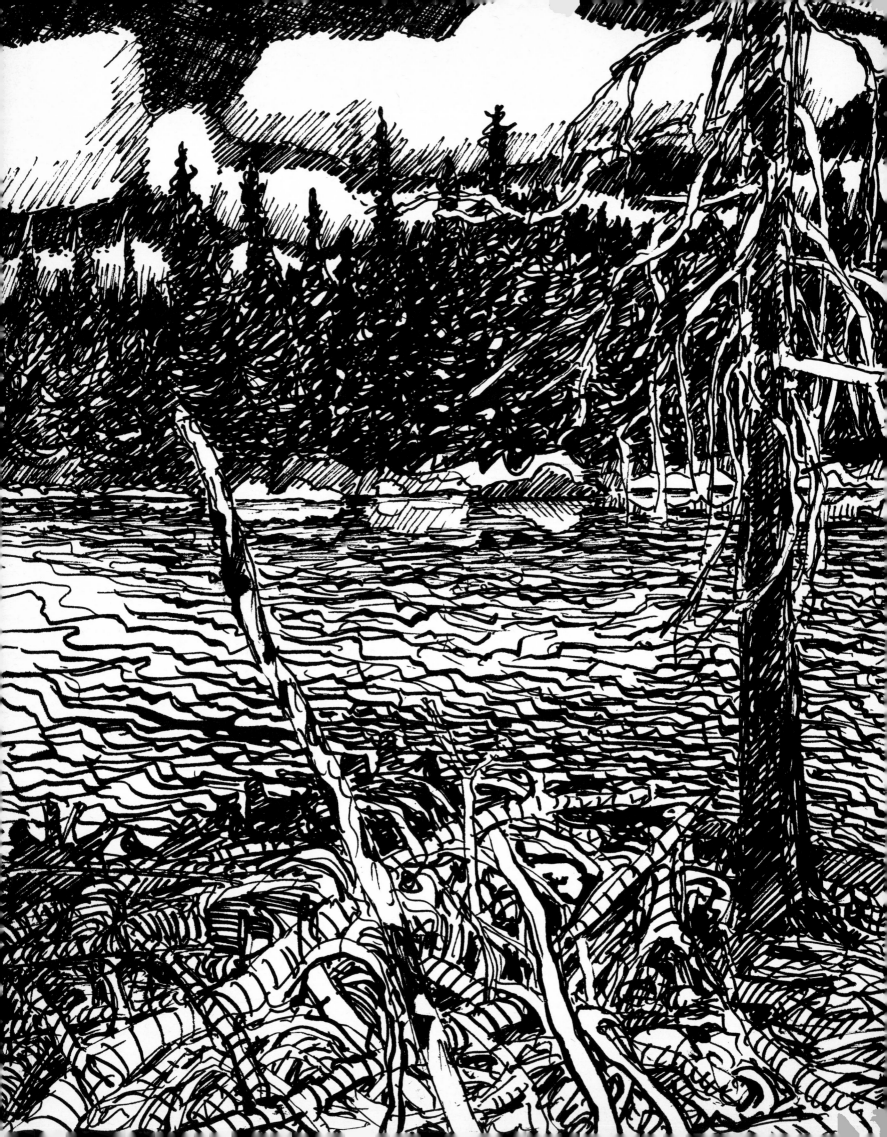

All afternoon
a sounding sea
is but now deep-a
sea is the ferment
nd and of torment
the tide all afte
coils lazily the fro
of amber kelp alo
along the shining
ut on the restless la
the heart the hear
he winds reluctantly
uctantly has died
ough never pounding
sturbs roused clou
re passes ever wh
cloud's lonely shad
bold shadow of b
sapphire sky
times upthrust
ainst the dark p
such white might
though no sound
rays the roused clo
e eyes weary from
m their dimmed dreamin
t will ease ur
d the heart will eas
l ease urge ease urg
orment tired the tid
ds of amber
ining rock

*

All afternoon
jade pounding sea
but now deep-drowned
the ferment of boulders
and of torment tired
the tide
coils lazily the fronds
of amber kelp
along the shining rocks

On the lagoons
of the heart
reluctantly
the wind has died
Though never pounding surge
disturbs
there passes ever
cloud's lonely
and bold shadow

At times upthrust
against dark green of pines
is such white might
that though no sound
tells roused cloud's rise
eyes
from their dimmed dream
lift
and heart
will ease urge

1935

*

Tossed cans clink on rocks
Fruit rinds dance like floating cups
in sunny suds
when elegant guests
have left the tea
The amber kelp beds lift
and fall and lift again
as an obsequious
foam-seething serpent
breathing green spume
streams his green-gold belly
up the gully's flume
lapping seagull's dribble
furry dewlap slapping
churning phosphate froth

Flashing over foam-flake
white-wave high
sea birds scream
against hard wind
while in the bay
blackfish flash
and catboats ride

Phosphate sea
froth-flecked sky
ignite with high
tide's mounting song of
singing wind
and sky's wild wing

1935

Vignettes for Hornby Island

I

Over to the West
a passing squall

launch heading out
explodes to foam

gleaming knife of light
across horizon

jettied boats
like whinnying maned colts
to stallion wind

breakers in the gulf

behind me
thrashing firs

near rocks shining

Downes' Point

heart a white bird

II

Silence of days
I am nothing

Morning prone on rocks
vibrating
to time's end

glass water
faint crinkle
velvet smooth
ripple caressing rock

occasional gurgle
sensuous sucking
sea licking
intimate crevices

million on million
minute scuttlings
small hoppings
anal openings
clam squirtings

faint far crawking
gulls lazing but
watching

black shard on
flapped wing across
near water
crow dropping oyster
cracking on rocks
at last ceasing
of squawks
tearing
eating

sour brine stench
seaweed drying

lapping of tide
gravel rolling
on gravel rolling

giant silver twisting
logs past passion

woods behind
faintly rocking
green fronds feathered

light
white
peace

silence of days

1971

Rockface

Tide's edge
against cliff

algebra of enigma

scoured
inscrutable glyph
rock
equals time
equals sea

ancient equation
ageless face

1947

Heron Bay

From what fuliginous coals are
smelted out the metal of his wings
to carbon-hardened blades?
Glittering July's death angel
is this harsh shard of darkness
darker than his shadow
on the seared grass
Lord Raven in his bony flight
scythes the dry air and
after much awkward fan-flap
and wing sheathing and
tipped precarious hold and
rattle of claw on parched branch
he is seated here
with spastic jerking head and
coiled spring tension
quite ignoring us
expecting the invader

Down low tide
on high boulder
acting sentinel
is Raven II
oblivious to the caravan camp waders and
the clam-squirt probers and
the tawny mothers in
old floppy beach hats and
their faded salt bikinis
Rigid now against the
nacreous gleam of water
head cocked in restless scrutiny
he sends out waves of menace

Raven III is up the slope
across dried field
on dead oak branch
peering hard and opening beak and
shifting foot to foot
seething

Fell work ahead
along these rocks
in the glass heat
The silvered voices of the waders
shiver in the air
The dried-salt pools
the spackled oyster beds
the burnished viscous ripple at the sand
are all in thrall
The woods above the bank are
charged with shadowy venom

On no seen signal
now the gangster ravens move
In swift equation
A to B
B to C
C to A

In far places lonely beds
wakening in dawn's desert sweat
tense with fear
waiting that barbed stark crawk
to pierce the heart
the scissoring of wings
the nameless shadow over
in cabalistic terror of next move
next day
A to B
or is it B to C
or C to A?

1971

82

I have watched the grave haze
of a summer evening
creep from every available hollow
when there's not
one fugitive
remembered cloud
on the sky
I have watched on the veranda
the slow toil of cigarette ends
rise straight and tall
into the clear air
poise coil falter
and then
die into night's descending

They might be the thin
burned-out escape of the soul
into nirvana
after the aged lips
mumble their prayer
as sinuously
they eat surely
their red way
down the pale stems
and the long cones of ash
in the silence
lengthen and drop

1934

Above the Harbour

Through hair's tingling
on the high clean air
the trembling reaches of the sky
trail their skeins of memory
down frail tracks
into the tendrilled roots of all my past
and running up and down these wires of sky
the thrumming echoes of all time
all place all history
are moving halting moving
rising and descending
as my mind extends
on this electric membrane
interweaving past and now
the immemorial to the instant
recognition shock

On this bold promontory too
the hair of grass is tingling
Here one is exposed
to the wide introspective world
I upon this bluff
can see my old notions
like the grey hulls that lie
locked in the roadstead's leaden seethe
the new
the hopeful unformed new
like white plumes
from ships moving out

1972

From Granville Bridge

Seeking the last sun
the ancient harbour
wrinkles its reptillian skin
toward the westering gold

At this lizard hour
the late August heat
bites at the shoulder blades

Crossboards of the iron walk
to centre bridge
are rattling loose
their rusted spike-heads
free from eroded treads
Black protective paint
along the rail
has blistered over orange sores

A lone street car
lurches up the ramp
with clattering roar
empty sun's glare
flashing glass panes
Screech of steel recedes
trolley flashing blue sparks
upwards against dark

Once more I am alone
Stale smell of dust
is in my clothes
Intricate metal tangle
of angled beam and brace
trembles with memory
of passage

Sour evening's breath
faintly from where
the harbour opens nacreous
is delicate ticklish fur
across my face

Elbows press rail
bone against steel
propping chin to keep
eyes against glare

In this suspended time
I am the dry stone desert
of myself

The evening traffic surge
has swelled and roared
people going home

Summer is a knife
I cannot tear my bonds
till it has tortured me again
as day wastes into day

Our city
I have thought as mine
my mountain there behind
etched to a razored rim
tonight is pocked
her teeth are carrious
her skin is old

She is an aging dynosaur
whose crumpled bones
are stretched before the mountain
Spinal crenellations are exposed
in callous scalpelry
of warehouse sheds and office towers
Sun's set tonight
a white and gold
carving to the heart

Version II

Old gravel mill
whose towering hopper
rears in ravaged grandeur

Tarted whore
who borrows
from the westering gold
her faded radiance
her teeth are carrious
her face is pocked
Her corrugated roofs
like shining armour once
are crumpled now
Beneath abandoned walls
the scuttling rat
Late August heat
warms her stark bones
Stale evening's breath
licks dust about her
Far too often
she has rendezvoused with rust

Her brave jaded splendour
is a sorrow
not for today's death
but for the no-tomorrow

Version III

Harried by the wind
and now picked clean by light
across the harbour's rim
toward the West
the city lies
like an exhausted victim
of the white and gold
The spinal crenellation is exposed
The sheds and towers
of vertebrae
are serially laid
like blood-dried bones
against the sky
A last slow convulsion
of the nerves
crinkles to August heat
the prone harbour
witness to the crime
wrinkling its revulsion
into gold cracks
toward the dying blaze

1934

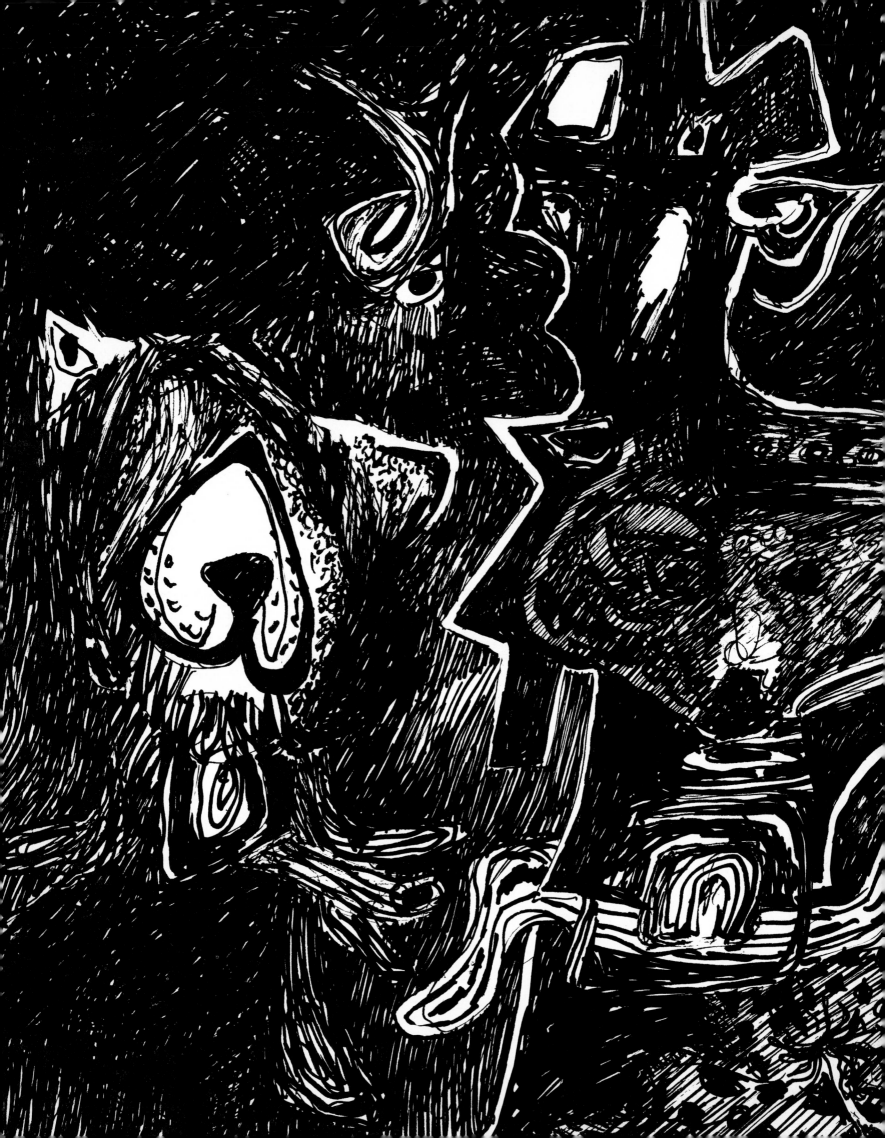

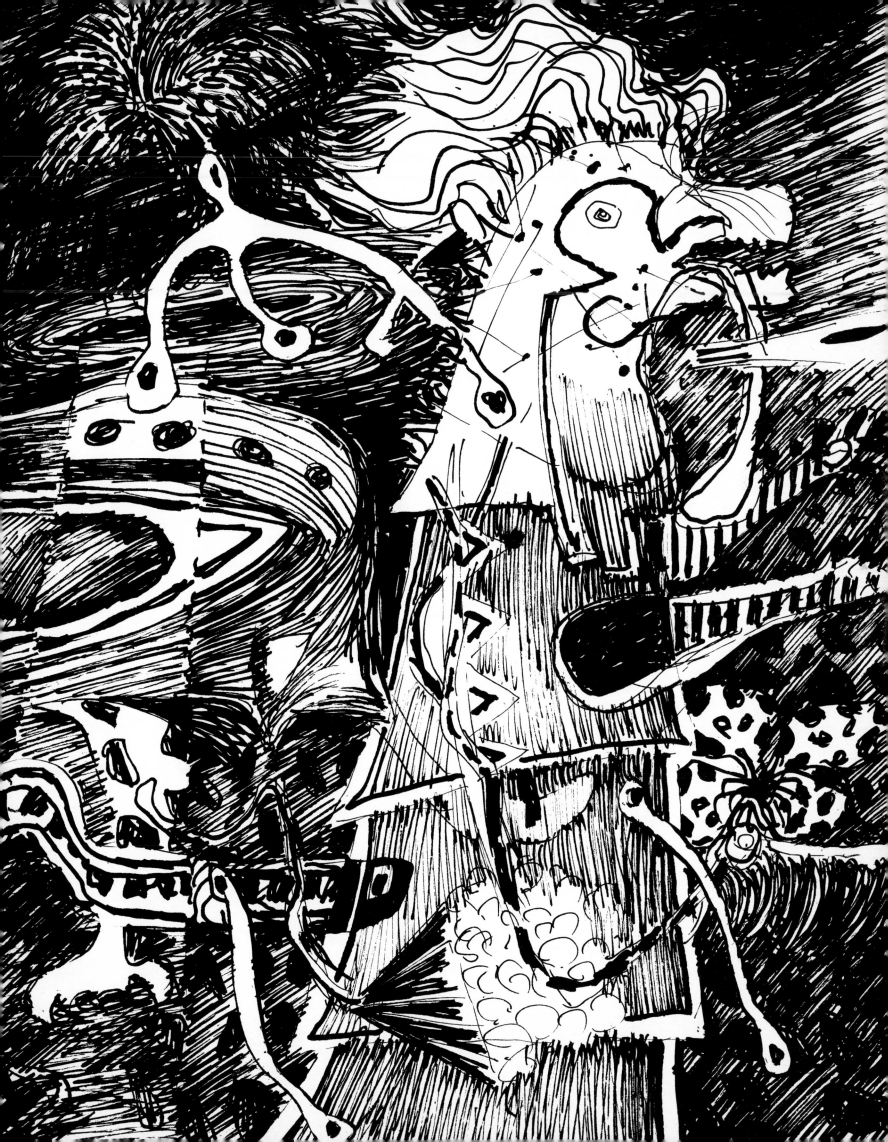

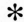

Tiger buds
the lion and the leopard flowers
grow in the quiet mind
sometimes I could move off
down secret paths
with fronds of dim forest
closing after me
deeper and deeper
into that forgotten world
where all my lost ideals
have grown into an Amazon

Every little hope
every little flower of innocence
every little soft forbidden lust
the touch of genital or breast
the moth-like lips in dream
the pale and orchidaceous blooms
of narcissism
weeds of doubt
lianas of despair
soft cankers of deceit
all have been nurtured there
in that erotic shade

If I could find that secret glade
where all around
the lush forest of my failures
the abandoned dreams
and tenderest sweet reveries
have blended in a jungle
tall and so mysteriously twined
into a dark seduction
I would stand I'm sure
silent on the deep mossy ground
whelmed by the memories invoked
irrevocably drowned

Therefore no secret path
no secret sign
into a secret forest's
unreality
Give me what I know
straggling resonant pines
spiked craggy firs
that rear their tall tangles
to the hawks and eagles
and the heron's nest
and if the rocks are bald
and hard and grey
and mustard yellow
and the line at sea's edge
is defined in whited salt
so much the better
for this clean astringency
The fresh breeze
the cold jade rollers
and the furled curling lip
breaking to spray
these are my thoughts by day
to chase the involuted dream
forever away

I thank God for islands
and for evergreens
and I eschew the fetid dream
the contemplation of the past
even at the risk of my path's
facing desert in between
Deserts at the best are
dry and hard and
can obliterate
only the lean survive
but the mirage at least is
always ahead

1972

*

Thank God for monkeys' bums
where at the shameless zoo
I learned at last in lonely glee
at first to giggle uncontrollably
and then to laugh out loud
among the crowd
at pink ridiculous obscenities

My hidden adolescence had been spent
in public playgrounds
seeking furtive glimpses
down loose drawers
of careless girls on horizontal bars
or legs foremost on the swings
Feverishly I gaped
for the dark flash between the thighs
or up the brown-stained hinder crack
or later down loose sleeves at school
to secret and revolting armpits
Nameless crevices
remained the things of fear
the dreads and fascinations of
my sweating dreams
somehow of tortured cats
or some revolting excrement

And still when we first met
in cleaning out the sink or
in the intimate bathroom encounters
with my loathsome self
the pimple or the blackhead squeezed
the poisoned echoes of my early quease
still lingered and
the nausea behind the toilet door

With shining naked loveliness
you made me whole
With easy vulgar laugh
at our absurdities
you took me quite beyond my furtive self
to golden ridicule of
secret blush at toilet's flush
The juices and the muck
no longer shamed
You gave me to the sunlit world

You made it possible for me
to give you love

1950

*

When they shall bloom me with the wax
and primp me for the plastic box
and park me in the phony nave
amid a plethora of flowers
and wafting from the organ pipes
a liquidiscent elegy
will swell in glory over me
and from the well-fed rector's chops
the words come sweet as lollipops
then when they file to view the corpse
(or contemplate the lost remains)
at that last look by those who dare to glimpse
beneath the waxen bloom
and cosmetician's primps
seeking in the face they knew
a momentary glimpse or clue
that there is more than this charade
to last them in the days ahead
some symbol to allay their fear
to rout all ghosts
indelibly carved clear
what shall they find?

Nothing I'm sure
Only some percipient person
peering hard might see
what by sheer habituation
might have still persisted through —
the bruised hurt look
a man will show
knowing she does not care
and he is staring at the mountain
on a Sunday with the weather bleak
and snow is in the air
and ashtrays overfull
and dirty dishes in the sink

1936-72

89

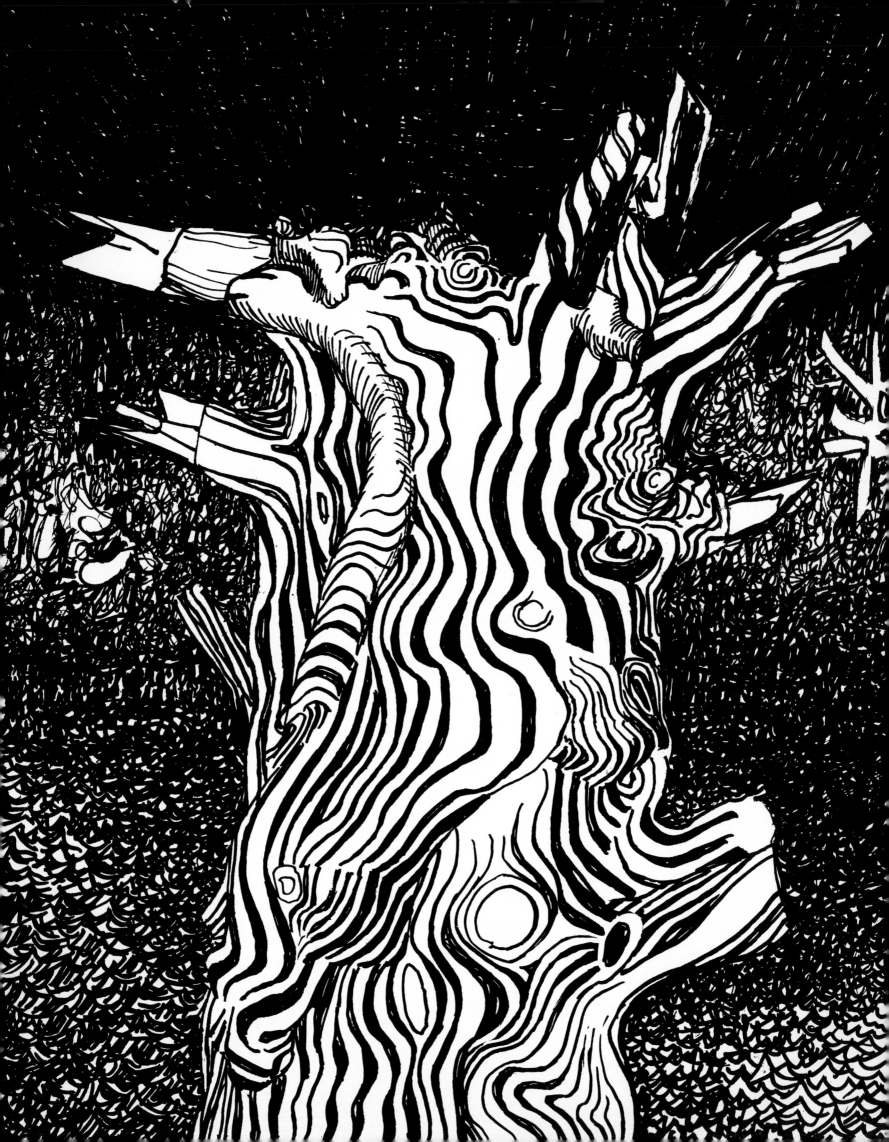

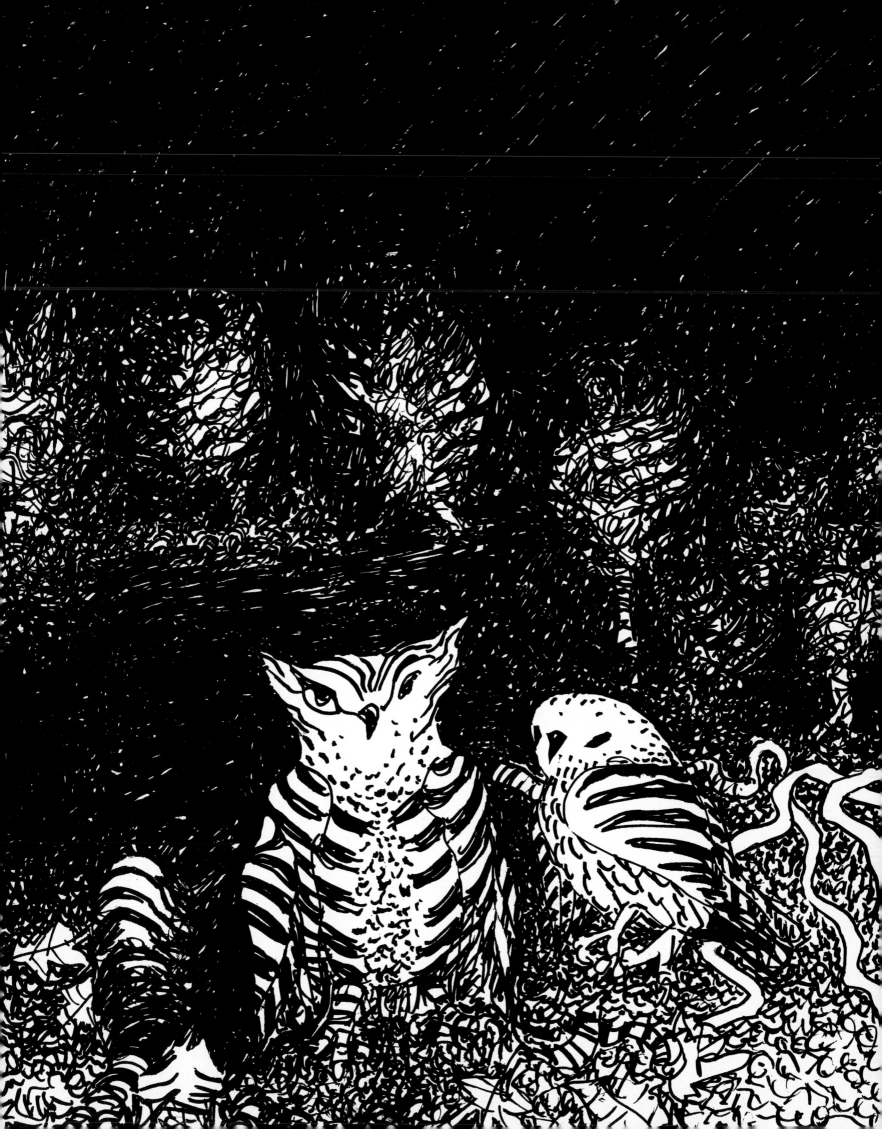

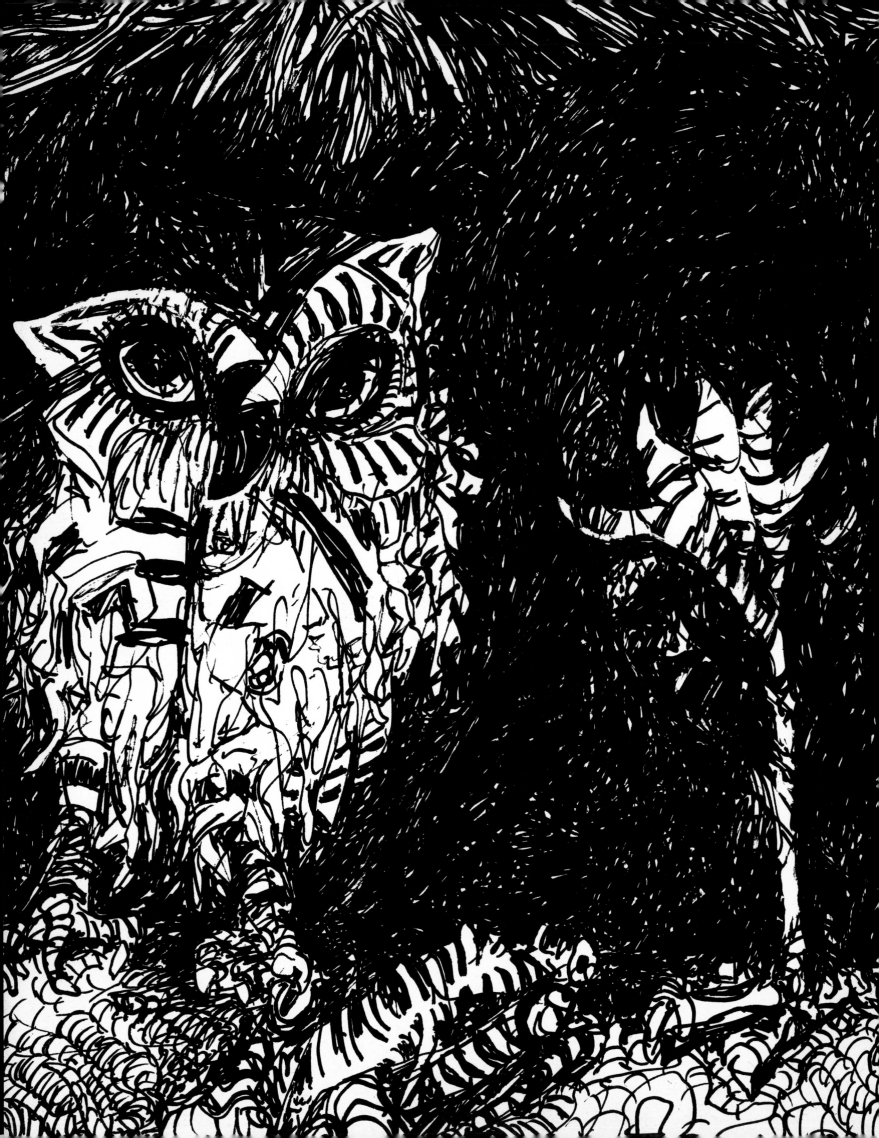

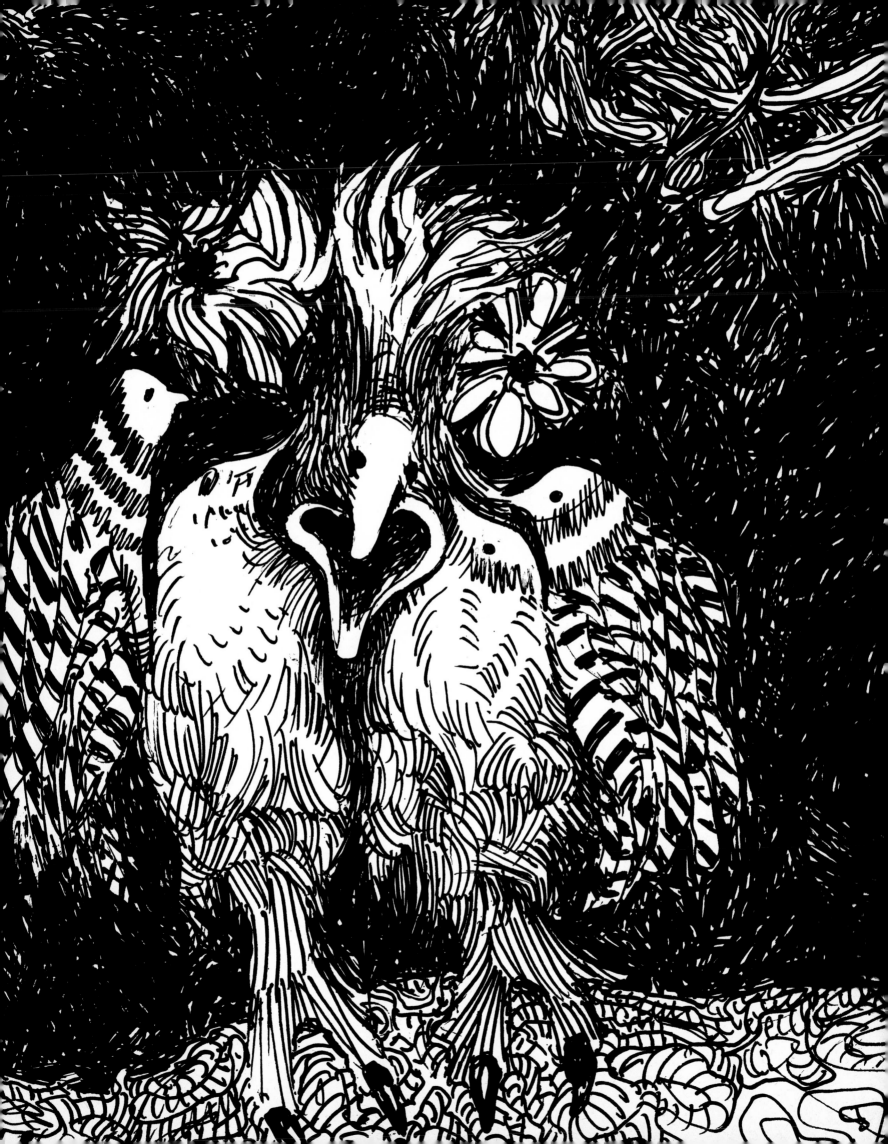

To a Young Horned Owl

Owliferous in glutted dream
his gut stirs
faint seismic ripple
under grey visceral skin
flicker of so faint convulsion
drawing feather roots up into
rolling bristle Dry
sussurus of celluloid rib
rubbing rib in almost inaudible
flick flick flick of feather
rising of ridge heaving and then
like silent wind ruffling
pale pin feathers has passed
Slight grinding of mandible beak on
lower hooded scimitar Behind
eyeballs a whitish turning upward against
blind glaucous hoods
Rope-like muscles contract down
spine and
sword-unsheathed wing feathers
fan bristlingly and
on clutch of branch minutest
prehensile tension stiffens
scales out around around
dry parchment bark radial
in panzer grip to
steel talon clenching
remembering
Dry scream sears
gullet to
inside hunger rousing slime-coiled
entralia to
squeeze oh squeeze oh squeeze
Pull red gut string
Convulse to
gleamed ruby bubbles'
sweet liquid spurt Oh
sharp acrid need Rip
to galled liver
Rend ductile bone

Splinter feathers Chew
breast and crunch skull then
salt-fresh
succulent so soft such
sperm-oozed eyeball then
anal stink and
white spew of orifice

King of dreams
on dark-blotched branch
invisible
Silent scourge
lord of near field
mouse terror
shadowed demon
menace above grass
cannibal
splatterer of limed shit
enjoy your gorged orgasmic
mouse-triumphant Auschwitz
small victim's scream decibelled
to mad shriek and
bugged dementia of eyes and
ghastly dribble
Soft fuzz-feathers juice with
rancid semen
Drool in your mean night
Falcons there are
who dote on little
owls There are
weasels who climb trees
There are jolly raccoons with
fine striped tails and large
inquisitive eyes who are not that
fastidious they too cannot
love little owls
as owls love little mice
as mice love succulent grubs or
whatever loves what

1971

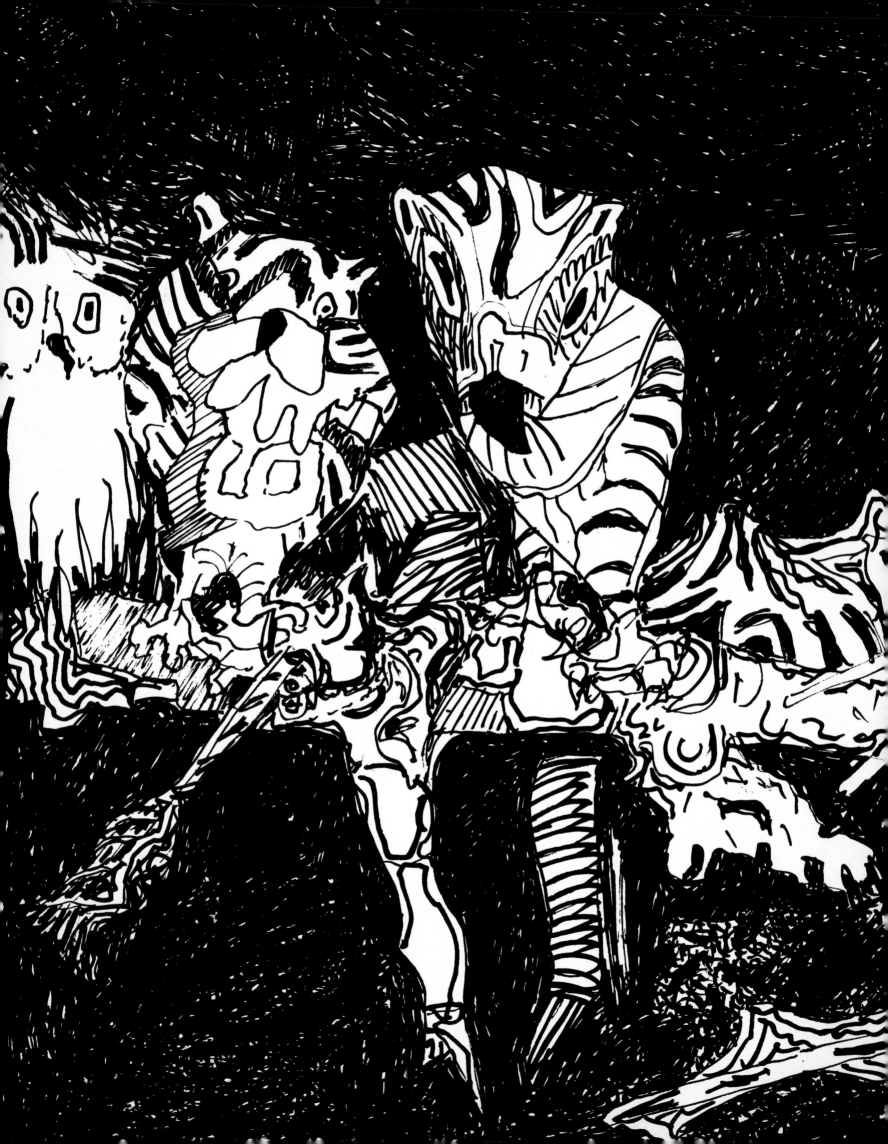

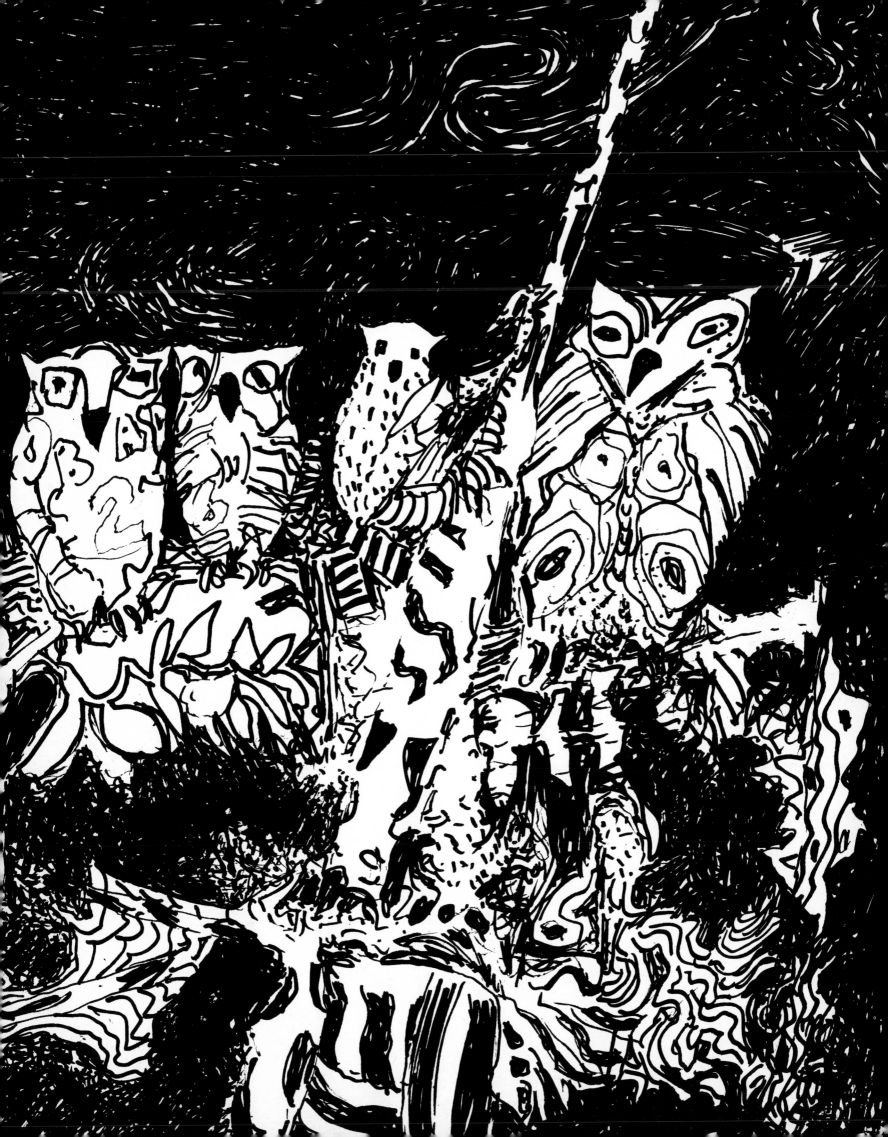

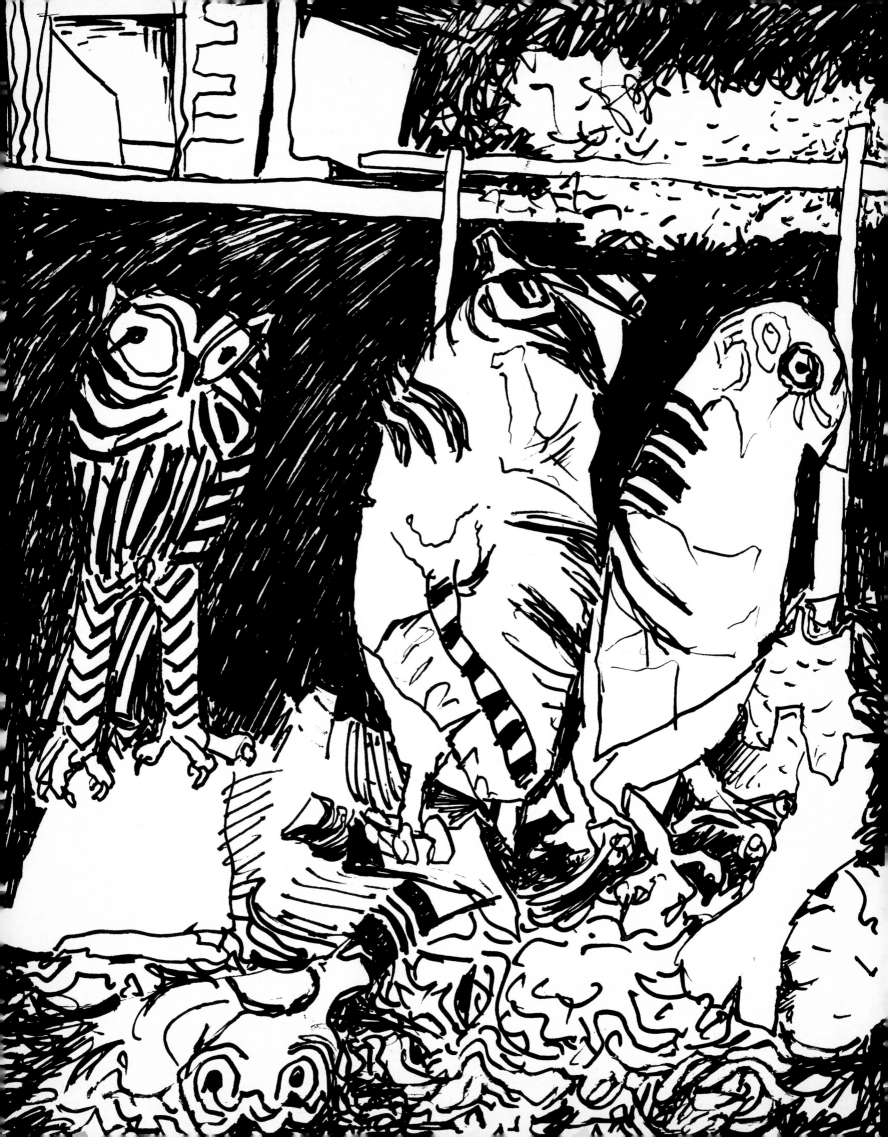

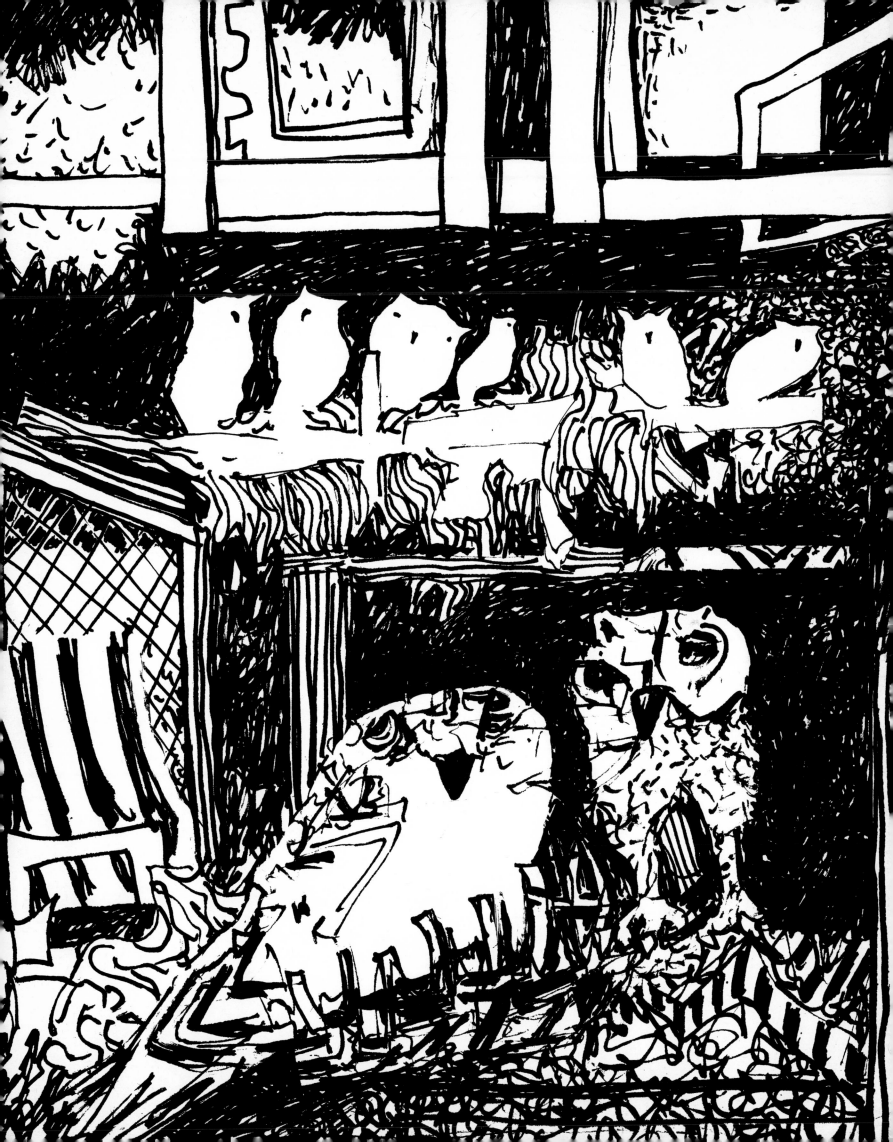

Fragments from Notebooks

Transformations

In rituals of reverie
a cat becomes an owl
becomes two birds
becomes a flower

When bird becomes an owl
becomes a flower
becomes a feathered flower
the flower becomes
my fowl-feathered friend

1971

Song

The silliwit and tit
flitter and flit
crows flop lazily away
wrens flip
thrushes fade
larks just disappear
bobolinks are here
and gone tomorrow
but the bird of sorrow
gliding on quiet wing
is here to stay

1935-72

Spider building high on air
his tensile engineering bridge
out over evening's vault
fashions daring metaphor
for all those of intrepid wit
and cunning who devised for us
structures of our bold thought
to span out space of mind
He gives an image for us like all those
who built things new and well
in lovely lifts of spirit
as he makes great dreams available
to mundane you and me
like the very silly but endearing name
of Isombar Kingdom Brunel

1973

Infuriating bee
the door to your immediate left
is open
has been for an hour
yet still you blindly rev
your futile motor to
intolerable pitch and
battle the impervious glass
that keeps you from your world
Can you not turn your
dogged head and scent that
freedom and the open air are
yours if you but
back an inch to
move around the frame

You rage until you drop and
then in tired dry crust
legs feebly kicking in the air you
dessicate upon the sill
in still August heat
with all of those who
died upon their backs because
they could not reconsider
blinkered flight to
move sidewise around an obstacle

1970

The pale erotic evening air
The scent of flowers by the shore
The fragrance out of atavistic time

We sit against the rocks
like ancient sages
stoned philosophers whose dreams
drift down the ages

1972

Make what you can of these
the facts of a specific evening
August 12 7.03 p.m. 1972
sitting on our deck
finishing a meal
braised beef potatoes
gravy richly brown and broccoli
endive salad
bitter-sweet dessert
Yago and more Yago
Conversation with my wife
and old friend visiting
all near and dear
and reminiscing
Harbour like gold lamé
mountains violet-brown
Outgoing slack
incoming tide
meet under Second Narrows Bridge
Scintillating energy
from molten slag
Burnished silver particles
between the bridge net's meshes
Time Place Particulars
all zero in to here and now
as we sit silently
before this nacreous green sky

1972

Party

Entering the room
he pushed before him
ghosts that we all knew
They mingled with the guests
each selecting whom
it most could home to
quietly enticing
backward reminiscence
till the room grew hushed

Man of loves and hates
the very virus
of his restlessness
charging our quiet air

We closed off breathing
and imbibed more alcohol
to disinfect the space
from his contagion

1941-42

Illicit sex is what it is
it has no euphemistic shades
Leave out endearments then
and call a spade a spade
Don't think to fatten me
with love's sweet flatteries
if you would keep this goose
that lays those golden legs
for then I must despise myself
for my hypocrisy
and in the doing so
end by despising you
The manifestly true sweet bitch
is easier to take
and oh I would prolong
as long as possible
this honestly dishonest state

1943-72

One more drink methinks
while breath still reeks
of beans and cabbage
and the gristled sausage
as I now re-script
the staled scenario:

I love you
You loved me
You now love me no more
You cannot bear that I should even touch you
This it is that cuts
I stretched my heart
and you contracted yours
yet hearts aren't made of rubber
so I hate you now
standing there consoling me
that you will not forget
what we once were
each to the other
Go Fuck off Just disappear
Your hero wants to blubber

1939-72

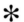

The forests in their majesty
brood above the quiet rocks
soothed by the sea
Lost in their dim recesses
I can know the creak and groaning
of eternity
Winds too high to feel
sway far above
the lacy tendrils
climbing on the sky
while here below
weakened by loss of light
lichened heavy branches
droop and ultimately drop
in moss-enshrouded silence

Standing here
on a lost ocean floor
in the dim tide of grey
almost at my back I hear
time's wicked buzz-saw
harrying near

1935-70

*

Go bird-watch a crazy coot
Go and cock a pretty snoot
Go and square an arrowroot
 My zany one

Go and catch your falling star
Put her in a B grade film
Jug her pretty brunette hair
 Capricious one

Go caress your summer tit
Callory your evening swallow
and be bold before a quail
 My mixed-up kid

Go and kill your little bottle
firing when the game is up
aiming at a million bucks
 Rapacious boy

An abacus she is my sweet
play with her beads don't count on her
dreaming of a likely tail
You will find your feathered chick
is not so dumb a cluck
 Unwary one

Then when you have burned your britches
and you're through with outer riches
I'll be laughing at the splash-down
crumpled by that pun
 Greedy one

1972

Tavern Song

She is a widow noble sire
she was a garden of delight
that now is overblown
where prickly thorn and roses grow
and cabbages and beets

Then I must cultivate this night
must hoe and hack her widow's weeds
and then replant with healthy seed
I must turn rake and comb her bed
and turn milady's tangled plot
to jasmine and forget-me-not

He whipped his piece
from out its pod
and cried "Heigh ho
let's plow the broad!
Here good varlet
take this firkin
I must off to jig and jerkin"

1938-72

Tavern Song

Oh she went West
wen I wuz due for Souf
Wiv the taste of 'er kisses
like rarsbries in me mouf
 Fer wich I bloody now
 av a unger an a drowth
Oh w'ere's me old ex-missus
wiv orl them rarsbry kisses
W'ere oh w'ere in 'ell is she?

It's the best little cavern in the town
w'ere my true luv takes 'em down
Wiv Lars an Bjorn an Eric
she reaches climacteric
Wiv er bouncin' and er jigs
an her bottom swingin free
she sets the rarfters shakin'
wiv er lewdish revelry
 W'ere oh w'ere's me missus
 wiv er stout an' porter kisses
She's a dear old tart
wiv a pudding for er 'eart
W'ere oh w'ere oh w'ere is she?

Oh I c'd ruddy drown
between me true luv's legs
'ow I'd like to see once more
me darlin' rump-sprung Meg
orl rosy on the bed
 Oh dear oh dear oh dearie me
 I've ad plenty of me new luvs
 but they're never like me true luv
Wiv 'er 'oarse guffaws and chatter
oh she'ad wat really matters
on a mattress on a spree
wiv 'er belly-button swingin'
an' 'er singin an' 'er swiggin'
we w'd drink life down
to the bottom of the keg
an then we'd both jump in the sea
 Oh w'ere the bleedin' jesus
 is me pink pearly missus
 wiv 'er gin-and-I-ty kisses
 an' the dimples on 'er knees
By the four saintly breezes*
of the holy father's sneezes
I wonder if she ever thinks of me?

*in very local mythology purported to be:
the fart, the snort, the sigh and the wheeze.

1938-72

107

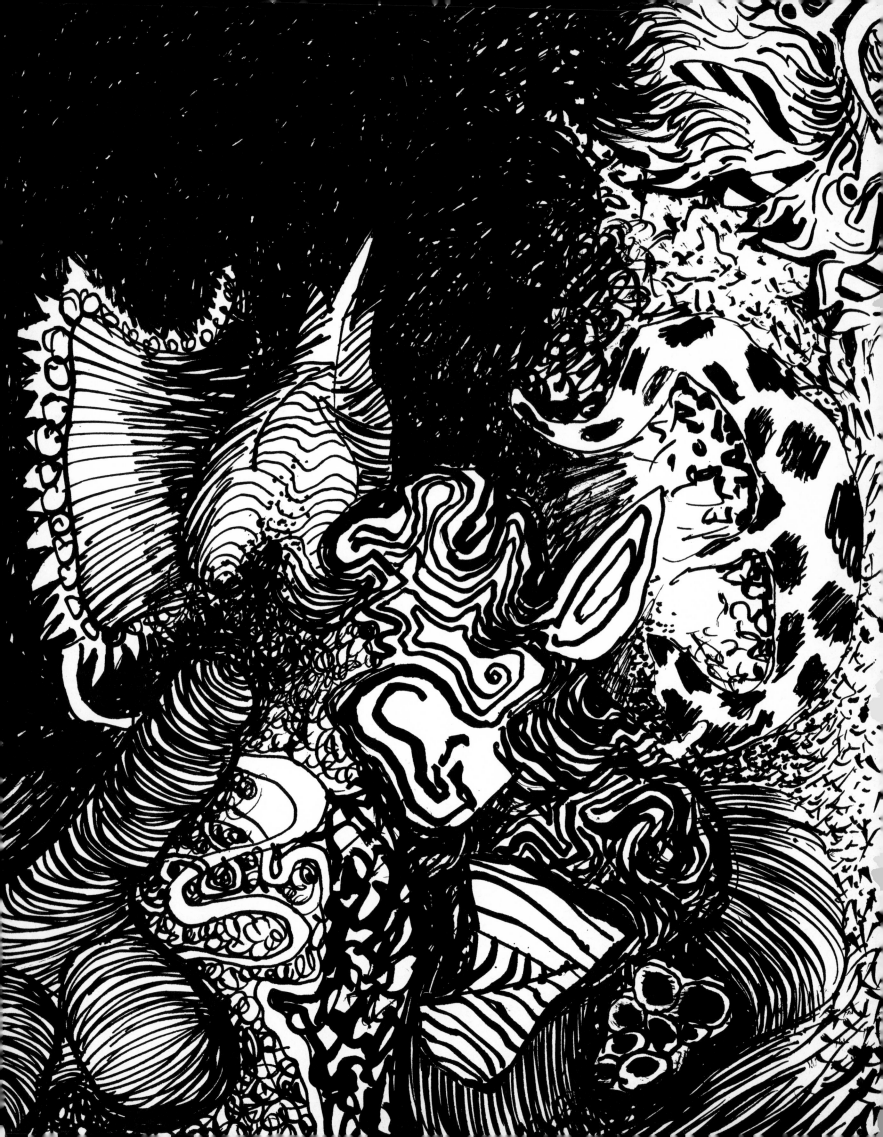

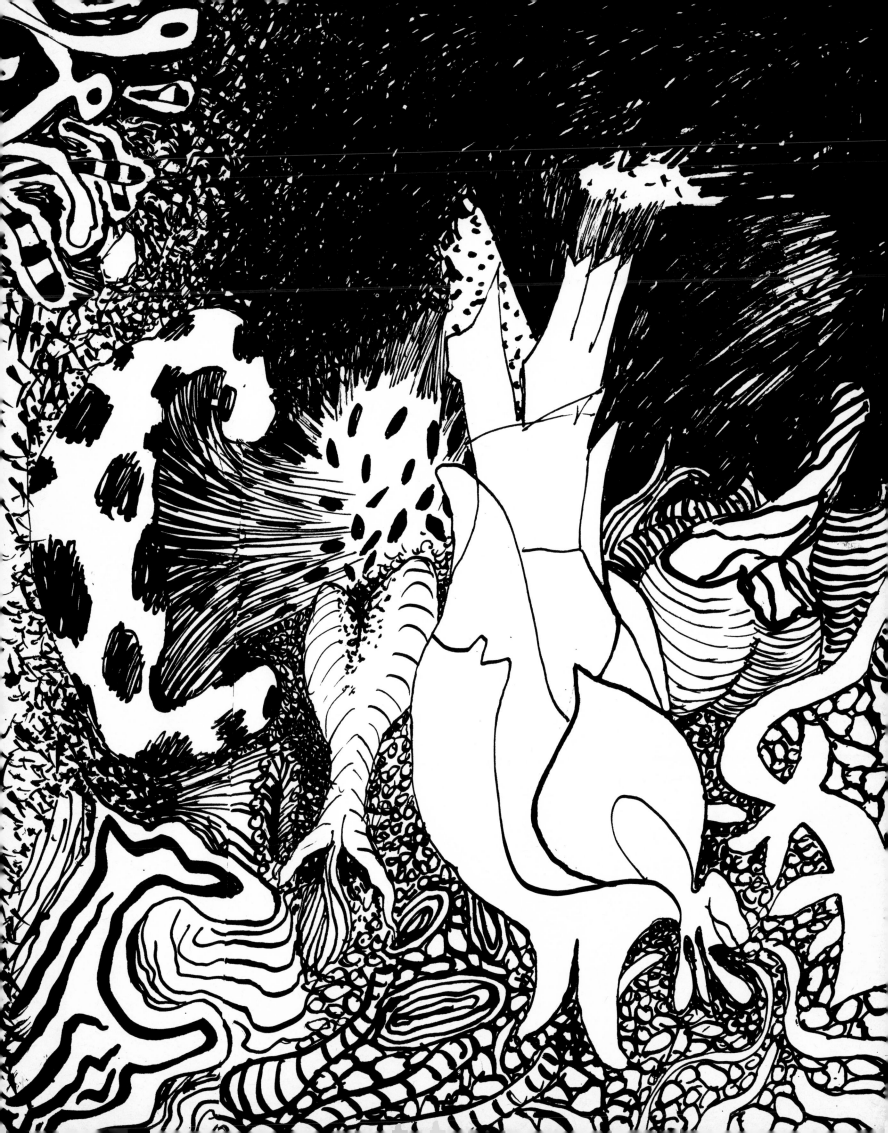

Index of titles and first lines

M7

JUL 23 '73